IMAGES
of America

KLINGBERG
CHILDREN'S HOME

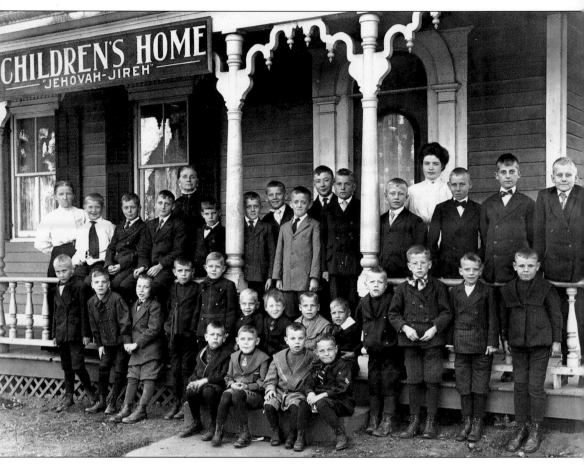

"Whoever welcomes one of these little children in my name welcomes me."

—Mark 9:37

IMAGES
of America

KLINGBERG
CHILDREN'S HOME

Mark H. Johnson

ARCADIA
PUBLISHING

Published by Arcadia Publishing
Charleston SC, Chicago IL, Portsmouth NH, San Francisco CA

Printed in the United States of America

Library of Congress Catalog Card Number: 2003104289

For all general information, contact Arcadia Publishing:
Telephone 843-853-2070
Fax 843-853-0044
E-mail sales@arcadiapublishing.com
For customer service and orders:
Toll-free 1-888-313-2665

Visit us on the Internet at www.arcadiapublishing.com.

To my wife, Linda, and our children,
Matt, Erik, Ali, and Rebecca.

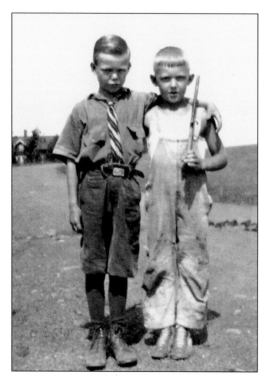

Two friends pose c. 1925.

CONTENTS

"They will soar on wings like eagles."

—Isaiah 40:31

INTRODUCTION

The Klingberg Children's Home, located in New Britain, Connecticut, was home to more than 2,000 children raised there beginning in 1903. In 1970, a transition was made from orphanage to family treatment facility, and it is now known as Klingberg Family Centers. John Eric Klingberg, himself having experienced a difficult childhood in Sweden, came to America in 1891 and eventually settled in New Britain. His concern for children who were abandoned and living on the streets culminated in the establishment of his children's home in 1903. John Klingberg, a man of exceptional faith, relied on God to provide for every need. This book combines many fascinating stories with photographs of the history of the Children's Home.

The photographs and history that are contained in this book have been taken from the extensive archives of Klingberg Family Centers. In addition to more than 2,000 photographs, the archives include John Klingberg's diaries, the beginning of an unpublished autobiography, and many of his other writings. Every Children's Home annual report published since 1903 is included in the archives. The reports contain stories of daily life in the orphanage and records of support received from friends across the country. There are also many newspaper articles written about the Children's Home, including those from newspapers across the United States and Sweden.

In addition to the vast amount of recorded material available, a wealth of information has been passed on to me by word of mouth. I have worked at Klingberg Family Centers for over 25 years, but my personal interest in the Children's Home has its roots in my own family history. My grandparents were Swedish immigrants who worked at the Children's Home during the 1920s. My grandfather ran the farm, and my grandmother was the seamstress. John Eric Klingberg was their pastor and friend. My father spent several early childhood years playing with his Children's Home friends in the wide-open spaces on the hilltop. During my own childhood, I enjoyed friendships with many children who lived there. Now, as a vice president of Klingberg Family Centers, I have met many more people who spent part or all of their childhood years at the Children's Home and have come back to visit and reminisce. All of these relationships have given me insights into everyday life at the orphanage and have encouraged me to compile this pictorial history. It is my hope that readers will enjoy viewing these photographs and learning about the Children's Home history as much as I have enjoyed writing about it.

—Mark H. Johnson
February 2003

ACKNOWLEDGMENTS

I owe a great debt of gratitude to John Eric, Haddon, and 'Don Klingberg for recording the history of Klingberg Family Centers via photographs, newsletters, news clippings, and other written material. I would like to thank the following for their contribution to this book: the Children's Home alumni who return to visit and tell the many heartfelt stories of life as a "home kid" and the Local History Room at the New Britain Public Library for locating several photographs that filled gaps in the story. Special thanks go to the following: Rosemarie Burton, a Klingberg president who supports and values the agency's heritage and leads with vision; my father, C. Howard Johnson, who through personal experience helped to identify the time and place of many photographs; my son Matthew Johnson for proofreading the captions; Dawn D'Amato and Linda Dischinger, who appreciate and value the archives and are committed to preserving the legacy and telling the Klingberg story. Finally, I owe a very special thanks to my wife, Linda, for encouraging and supporting me in the writing of this book and for her hours of editing.

One

THE EARLY YEARS
1867–1922

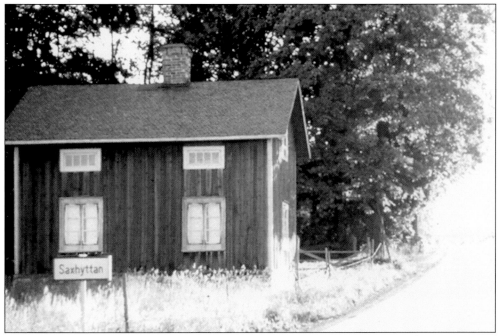

John Eric Klingberg's story began in the small village of Saxhyttan, in the province of Westmanland, Sweden, where his ancestors were farmers. He recalls the people in this community as "honest, earnest and somewhat religious." Their houses were neat and clean, and almost all of them were dark red with white trim. He said, "Among the places upon the face of the earth that I love to think about, Saxhyttan is one of the greatest and grandest. My soul has its roots there, and the very dust of its roads entered into my blood when I was a boy."

John Eric Klingberg was born on November 3, 1867, in this primitive farmhouse in Saxhyttan. He was the second of seven children born to Lars Eric Larson and Charlotte Persdotter. He later wrote that his father seemed unable to adequately provide for his family, even though he tried, and they were often destitute.

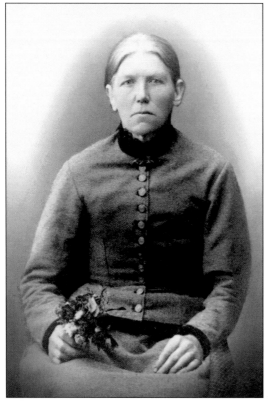

John Klingberg's mother, shown in this photograph, did all she could to compensate for her family's impoverished condition. She taught her children the doctrine of faith and hard work, and she practiced it every day in raising them. She would tell her children, "Hard work solves many problems, and you should never seek an easy life."

A man who came to Saxhyttan every spring to repair fishing nets bought John Klingberg three books: a New Testament, a catechism, and a biography. The biography, *The Life of Elihu Burritt*, was the story of the "Learned Blacksmith" from New Britain, Connecticut. Klingberg believed that God must have sent him his beloved book. He memorized it, and it had great influence on his life. From that time on, he began to dream about someday seeing the city of New Britain in America, the city he would eventually call home. Pictured here is Elihu Burritt.

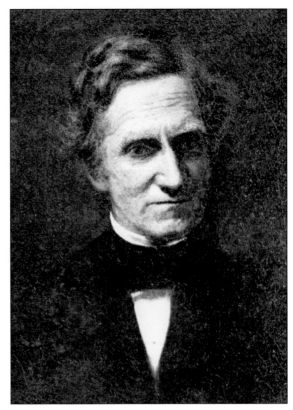

At the age of 18, John Klingberg left home to make his way in the world. He found work in Kolsva, an iron-mining and milling center of Sweden. He recalls the warm reception he received from a number of Christian families living there "whose religion expressed itself practically in a concern for my welfare. They welcomed me into their homes and invited me to their chapel where they met for worship and fellowship."

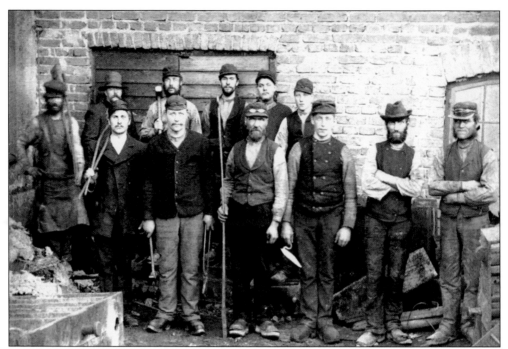

Standing with fellow employees at the Jader Iron Works in Westmanland, Sweden, in 1888, is John Klingberg, with a trowel in his hand and wearing wooden shoes (third from the right). The company superintendent, Erik Gison Odelstjarna, requested that John change his last name because there were too many Larsons, so John Eric changed his name from Larson to Klingberg. Why he chose the name Klingberg remains a mystery.

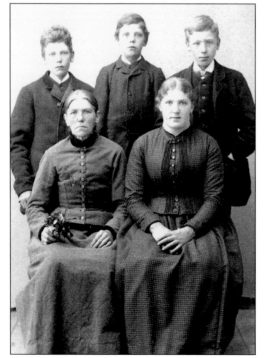

John Klingberg, thinking back to his youth, called himself a "dreamer and a wanderer." At the age of 22, he decided to find a new life in America. He visited his mother to say goodbye. Pictured here are some of the family members he left behind in Sweden: his mother, sister Hannah (who would eventually join him), and brothers Nils, Per Julius, and Arvid Wildhelm.

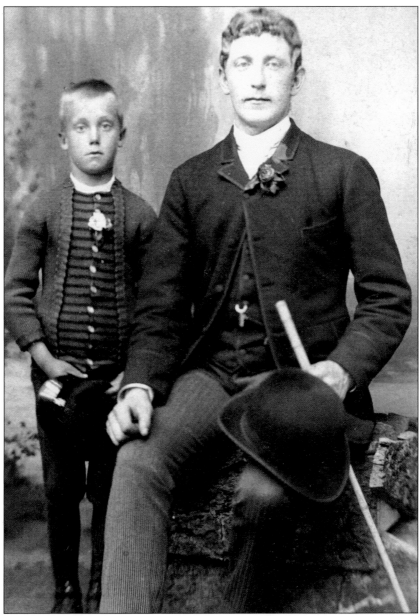

John Eric Klingberg sailed from Sweden on July 15, 1891, and arrived in Boston three weeks later on August 4. From there, he found his way to the Swedish district in Chicago, Illinois. Standing next to Klingberg in this photograph is Conrad Beckman, a son of the family with whom he boarded. Klingberg said that he felt at home in this country from the very beginning, so on his second day in Chicago, he applied for citizenship. Given his experience in the Swedish iron mills, he found a job with the Ajax Forging Company. Referring to his new life in America, he later wrote, "Free and happy I took the days as they came. I had nothing to regret, but everything to hope for. I was as mighty as a king and the whole world was my empire. 'Imaginations and youthful dreams,' I hear someone say. True, but it is fascinating to the youth to feel that way. His inner life is enriched, his horizon is enlarged, his sympathies are widened. Such thoughts make him feel better, breathe easier and fight the battles of life more courageously."

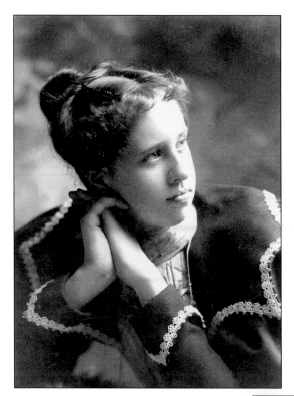

In November 1893, John Klingberg was baptized and joined the Salem Baptist Church in Chicago. He felt the call to become a minister, so he enrolled in the Swedish Seminary and the American Academy, schools at the University of Chicago. During that time, he met Magdalene Ericson, shown here at age 17 at about the time she and John met. They began a lasting relationship. In the spring of 1898, John graduated from seminary and was ordained a Baptist minister.

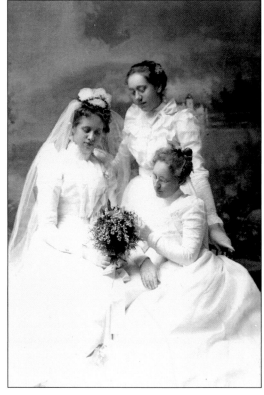

Magdalene poses with two of her sisters on her and John Klingberg's wedding day, March 8, 1899. Reflecting on his own difficult childhood, John wrote that because Magdalene enjoyed being raised in a good and wholesome family, he "shall always have reason to praise God for giving such a good and suitable helpmate."

During the first year of their marriage, John was the pastor of the Salem Baptist Church in South Chicago. In addition to homemaking, Magdalene taught Sunday school and played the organ at the church. They also read the Bible from cover to cover during that time.

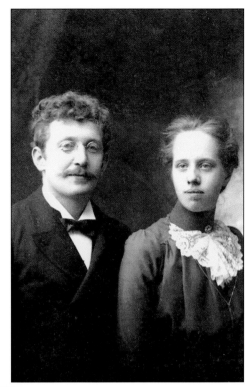

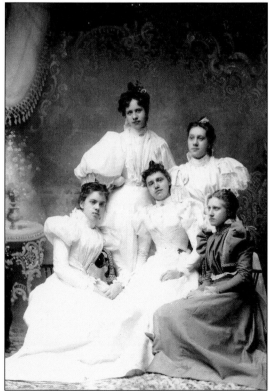

In the summer of 1900, John Klingberg accepted an invitation to become the pastor of a Swedish congregation in New Britain, Connecticut. Even though it was difficult to leave family and friends behind, he and his wife believed that God was calling them to this small New England city. This picture shows Magdalene (back row, left) and her sisters.

John Klingberg became the pastor of the Swedish Elim Baptist Church, located on Elm Street in downtown New Britain, half a block from Main Street. Having read as a child about the city of New Britain in Elihu Burritt's book, and having had a lifelong dream of visiting there, it was confirmation to him that this move was indeed in God's providence.

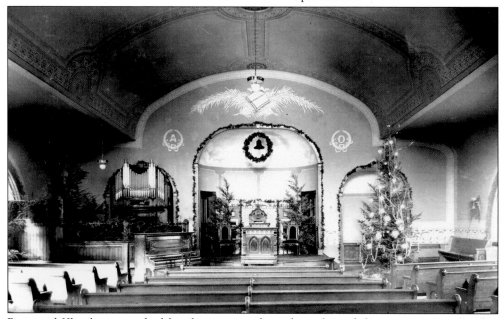

Reverend Klingberg preached his first sermon from the pulpit of this sanctuary in October 1900. Because the congregation was made up of Swedish immigrants, his sermon was delivered in Swedish.

In 1903, John Klingberg began to think about doing something for "boys and girls in needy circumstances" but saw no possible way of doing it. He was beginning to believe that God wanted him to "do something for the little folks that could help them and at the same time, do something that would honor His name." He "gave the matter much prayer," but in sharing the idea with his friends he found no support. They thought it was an admirable aspiration but that it was certainly not for him to undertake.

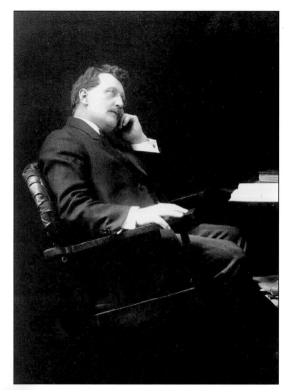

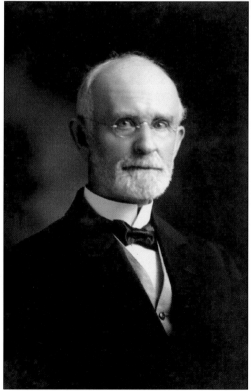

After more thought and having written down his idea, John Klingberg sought someone in whom he could confide and who would give him wise counsel. He went to Rev. Lyman S. Johnson, pictured here, New Britain minister and city missionary. When Klingberg told him why he had come, Reverend Johnson became serious and thoughtfully questioned him. After a thorough explanation, Klingberg reported, "His saintly face shown as he answered: 'Yes I understand, and I think you are right (to pursue the plan); may God bless you.' His words removed my doubts, his prayer strengthened my hands, and his gifts enabled me to carry on the work for several months." (Courtesy of the Local History Room, New Britain Public Library.)

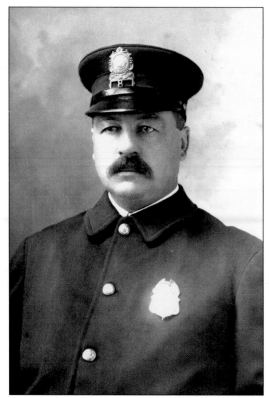

Reverend Klingberg's plan to help abandoned children was finally put to the test on Sunday evening, May 20, 1903, when on his way home from church, he was stopped by New Britain police officer Charles M. Johnson, shown here. Johnson said that there were three boys abandoned in a hut on the edge of town and that he wished someone would go and take them away and give them a home. After securing more details from Officer Johnson, John went home and, believing this was a sign from God, came to the conclusion that it was time to take action on his plan.

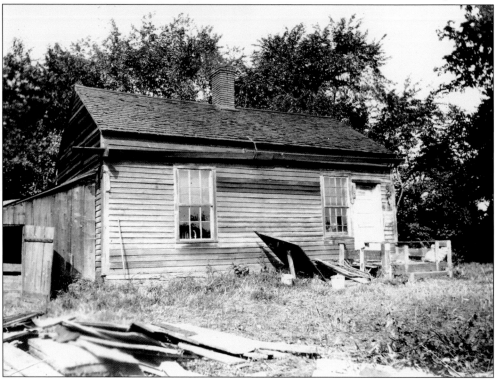

The next morning, John Klingberg went to the shack and found these three boys, brothers, abandoned and left to fend for themselves. They were scared and hungry, so he comforted them and, gathering them up, brought them home to his wife.

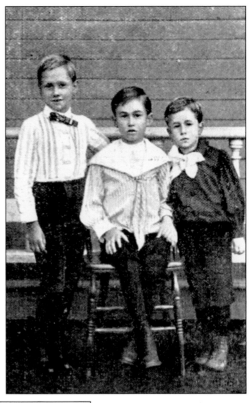

When John Klingberg and the three boys arrived at his Garden Street home, shown here, they were met at the door by his crying wife. John and Magdalene already had two small children—Mabel, who was three, and Haddon, who was two. John simply told Magdalene, "Don't cry wifie, these boys are a new addition to our family." She bathed and fed them, and the Klingbergs kept them in their home for about a week.

19

John Klingberg knew that it was not practical to continue to keep the boys in his home. Without money, furniture, or anyone to help care for them, he prayed for help, knowing this was God's plan and trusting Him to provide what was needed. John went out walking, as he later related, "not knowing where I was going," and ran into Charles L. Barnes, who told him he was looking for a tenant for a house he owned at Ozone Heights (Victoria Road). John told Barnes that he was looking for a place where he could start a home for destitute children, and Barnes agreed to rent the house to him for that purpose for $10 a month. Another man, whom John had met the day he brought the boys into his home, offered a bed, mattress, pillow, kerosene stove, and two window screens, which were delivered to the house at Ozone Heights, along with a few kitchen utensils and plates from Magdalene Klingberg's pantry.

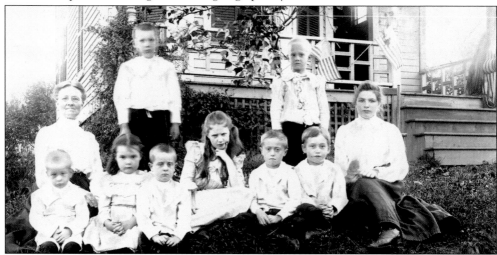

Having secured a place for the children to live, John Klingberg now needed to find help to care for them. A woman from his church volunteered. Leaving her own home, she cared for the children for the first week. All she had to use was the few donated items and $1.50, the only money John had to give her. Later reflecting on the woman's generosity, he said that he did not know where she had slept, because there was only one bed for the three boys. More women from the church volunteered to help out, one after another, for the first few months.

In August, a young woman named Florence Pierce arrived. Believing in the mission of Klingberg's new Children's Home, she moved in with the children, becoming the first full-time matron. Two weeks after moving into the house on Victoria Road, it was well furnished. John Klingberg said, "People took pity on me and helped me, not because I had done something good, but they thought . . . there was something missing in me." He did not go to the trouble of determining their motives but accepted the help and then thanked God. He realized, "What was lacking in outward comforts was richly and abundantly made up by inward blessing. We were so content. God smiled upon us, our joy was not diminished by the things we did not have, but was rather increased by the things we expected to get."

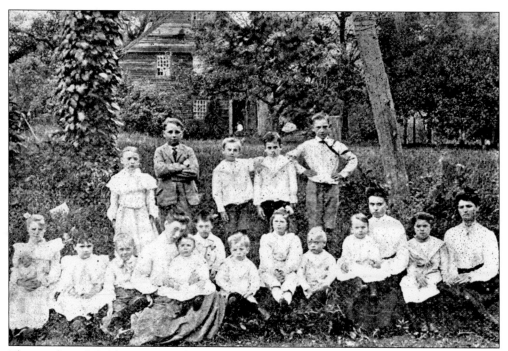

The number of children increased steadily over the next several months, thereby outgrowing the house on Victoria Road, which slept only seven comfortably. John Klingberg began a search for a larger house.

A larger house, in which as many as 35 children could reasonably be cared for, was purchased for $1,125 from Dr. Alfred C. Cooke. It was located at the intersection of Corbin and Black Rock Avenues, known as Cooke's Corner. By Christmas 1903, 18 boys and girls made their home here.

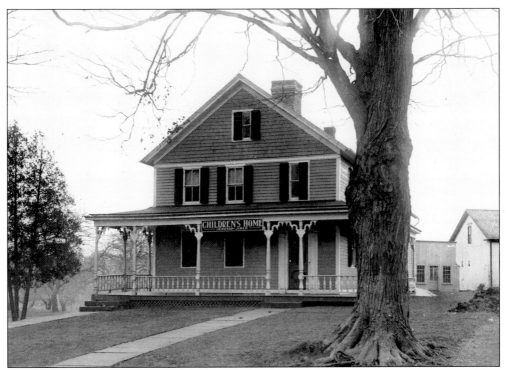

Throughout the history of Klingberg Family Centers, this house (no longer in existence) has been remembered by the eight-foot black-and-gold sign that John Klingberg hung over the front porch in 1904. It read, "Children's Home" in large letters, with "Jehovah-Jireh" in smaller letters underneath.

CHILDREN'S HOME
"JEHOVAH-JIREH"

John Klingberg hung this sign on his Children's Home, publicly acknowledging his faith in Jehovah-Jireh, an Old Testament name for God, meaning "the Lord will provide." Reverend Klingberg decided never to ask anyone for help but to rely on God's provision for every need in answer to his prayers. One story of God's provision concerned the admission of a young boy. Klingberg was called one morning and asked if he could accommodate another child. Having said yes, he realized that he had no more beds, so he immediately prayed that one would be provided. Later in the day, when the new boy was coming through the front door, a bed was coming through the back door, an unexpected but timely donation. Today, this sign hangs in the development department of Klingberg Family Centers.

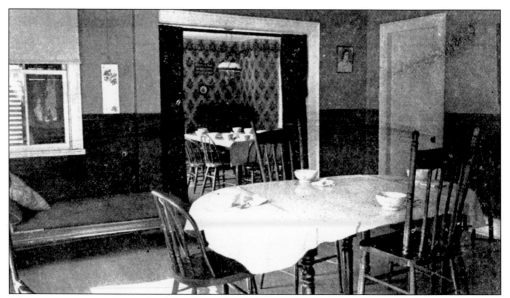

These are two rooms in the house at Cooke's Corner. The dining rooms were very simple but neat and clean. The reception room, or living room, had a pump organ, donated for the children in the first year. The hand-carved ship model on the wall was one of two owned by the Children's Home, probably made by a local craftsman.

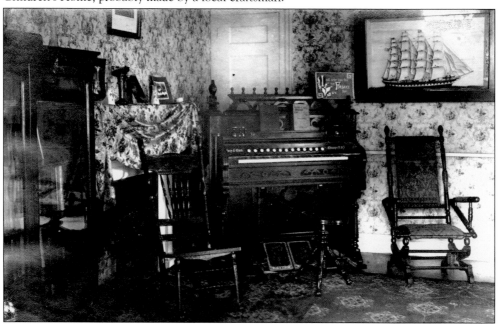

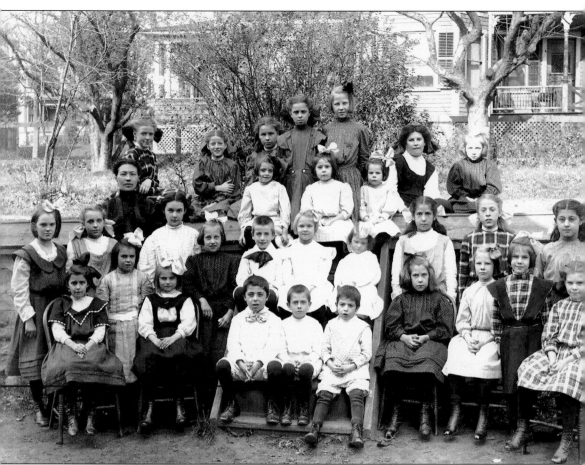

The first annual report was published in 1904. It reported that 22 children were given a home during the first year and listed the cash and items "sent in answer to prayer" totaling $1,296.74. Each gift was listed with the amount given, what town and state it came from, and any comments from the donor. As the months went by, donations were being received from across the United States and Canada. Two small Sunday schools in Rat Portage, Ontario, had collected $16.70 to start a library but decided to send the money to help the orphans instead. A woman in Worthington, Minnesota, sent $10 and a quilt she had made in celebration and as offering of thanks to God for 50 years in her church. A man sent $10 with the following letter: "Dear Bro. Klingberg, Many years ago when you were a student I met you on my way to school. I had a butterfly in my hand and you asked me what I intended to do with it and if I would let it loose. As I liked you very much, I did as you told me, but I thought it had been better if I hadn't met you just then. But my sorrow was turned into joy when you gave me five cents for the freedom of the butterfly, and now I will give you five dollars for the Children's Home, or one dollar for each cent you gave me when I was a boy. My mother also sends five dollars for the Home." As seen in the photograph here, the number of children in the Children's Home continued to increase until they had filled every space. It was thought best to expand by adding another house and, at the same time, to separate the girls and boys.

Pictured here is the Howard T. Sherman House, on West Main Street west of Black Rock Bridge. Beginning in 1904, it was rented as the first girls' house of the Children's Home. As soon as the move was made from the house at Cooke's Corner, and with ample new space, several additional girls were admitted.

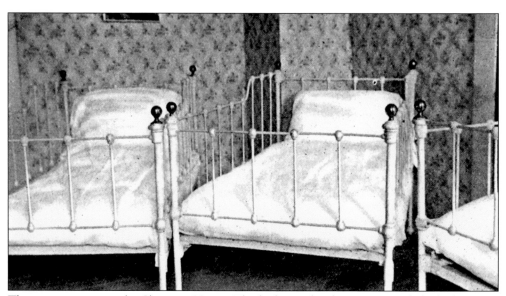

These rooms were in the Sherman House. The bedroom for the younger girls had white iron beds, like those of the older girls, but with sides to prevent children from falling out.

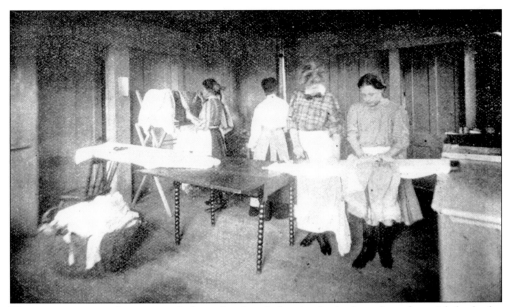

This room is set up for ironing. Judging by the clothes in the basket, these four girls had a lot of work to do. All of the work in those days was shared, and everyone contributed according to her age.

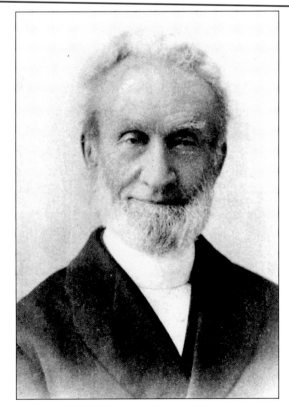

In late summer 1904, John Klingberg acted on his long-held desire to go to Bristol, England, to visit the orphan houses established by George Muller in 1832. It was Muller's example that had inspired him to rely on prayer for his needs to be supplied. This photograph shows Reverend Muller at the age of 92 as he appeared in an early Children's Home Almanac.

It was James Wright, George Muller's son-in-law, who welcomed John Klingberg as a friend and brother. Klingberg said of their visit, "It pleased him greatly to hear how the Lord had blessed my efforts. He encouraged me to trust in God in all trials of faith and external difficulties. My meeting with this Christian gentleman left a deep and lasting impression on me. Through his generosity I was able to extend my journey to my Fatherland, Sweden, where I visited friends and relatives."

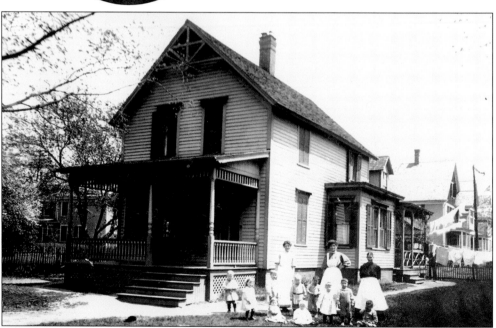

On February 12, 1907, in order to accommodate the growing number of children four years of age and younger in his care, John Klingberg rented this house from W.R. Hadley. Located at 20 South Burritt Street, it was not far from the boys' house at Cooke's Corner and the Sherman House for the girls on West Main Street, all in southwest New Britain.

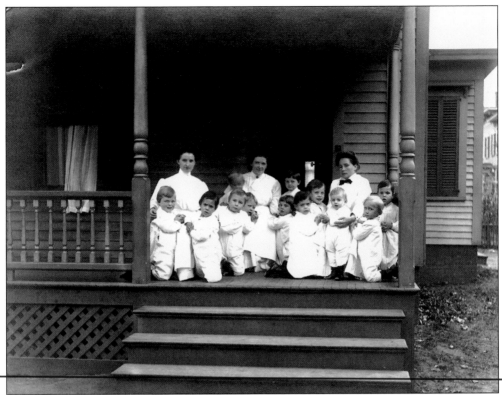

According to this group picture taken on the front porch of the Hadley House, there were 12 young children living there with three matrons. Nine babies and toddlers kept two matrons very busy at mealtime in the Hadley House in 1907.

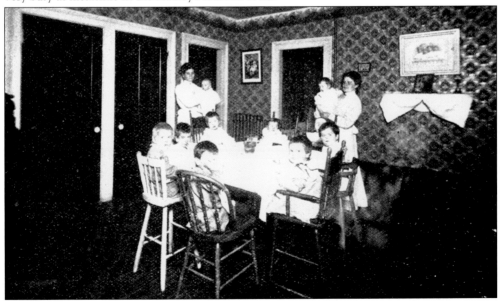

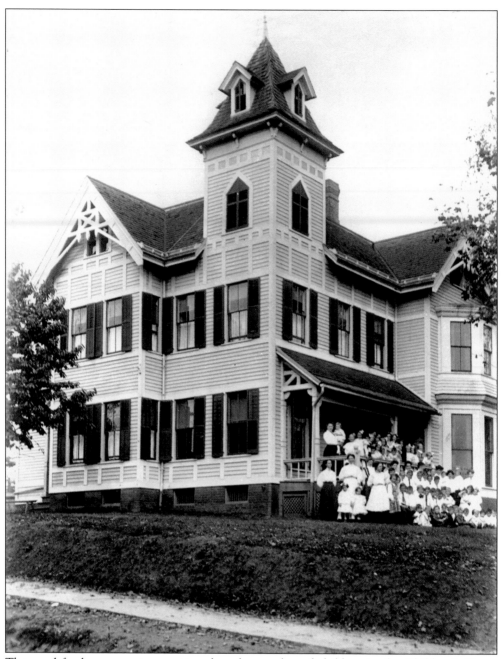

The need for larger quarters continued as the number of children in the Children's Home increased. In 1907, the girls moved from the Sherman House to the more spacious Burr House, on the corner of Griswold and Hart Streets. The house had been the residence of the late Judge Burr.

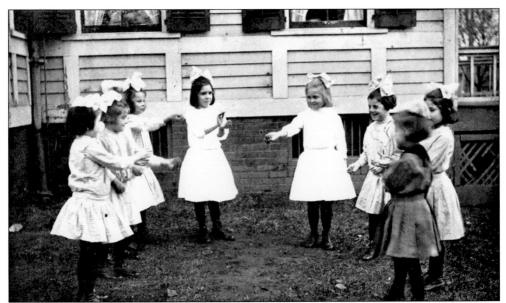

Girls attired in dresses and bows enjoyed playing in the spacious side yard of the Burr House.

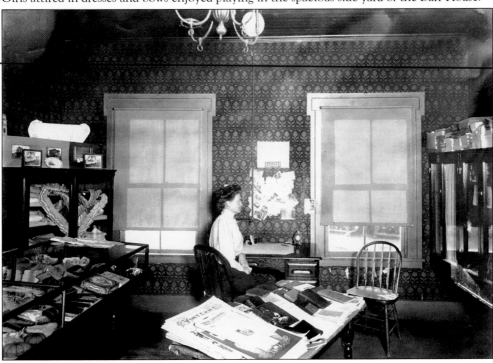

John Klingberg operated a tract and Bible room in downtown New Britain where he sold Bibles, distributed informational tracts, and sold for cash items that had been given to the Children's Home for the benefit of the orphans. According to the Children's Home annual reports, he made some money selling the printed materials and gave it to foreign missions and the poor, but he also gave away many Bibles and New Testaments. This room was first located on the corner of Main and Chestnut Streets. It was then moved to 157 Main Street and was finally situated at 103 West Main Street.

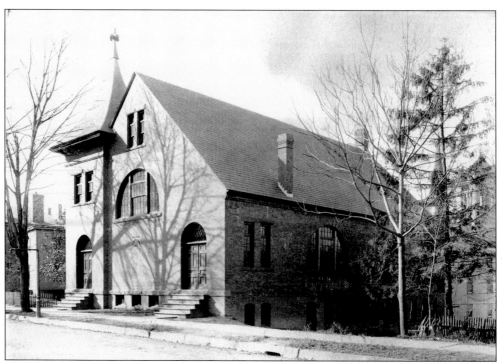

John Klingberg continued as pastor of the Swedish Elim Baptist Church, even as his responsibilities in running the Children's Home increased.

At a church business meeting in 1910, Reverend Klingberg presented a letter to his congregation, outlining his plan to give up his church salary of $800 a year and trust God to supply his family's needs, just as He did for the needs of the Children's Home. In this photograph, Klingberg is in the center, with members of his congregation all around him.

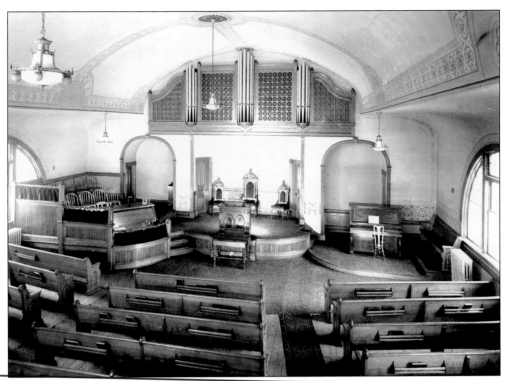

The members of Elim Baptist Church accepted Klingberg's plan but told him that they would place a box in the foyer of the church for anyone who wished to make private contributions to him. As seen in this drawing by one of the Children's Home girls, Klingberg continued to preach each Sunday at the church.

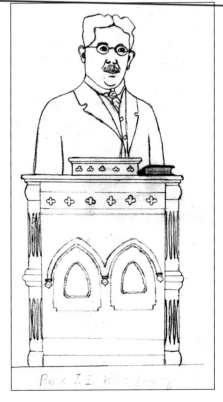

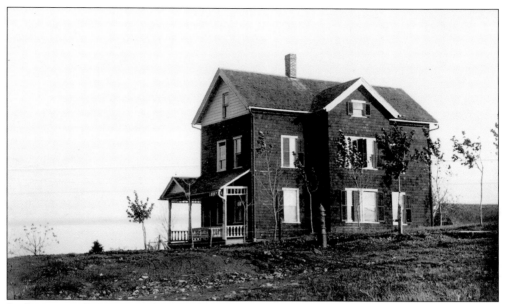

In the spring of 1911, an eight-room house was purchased on Rackliffe Heights. It was repaired and fixed up as a residence for older boys. Included in the property were a barn and pasture, and so began the Klingberg farm. This was the first property purchased on the hilltop that would become the permanent site of the Children's Home. It remains the site of Klingberg Family Centers today.

The barn at Rackliffe Heights is pictured in 1911, before it was expanded several times over the following years. Girls living at the Burr House, at least six blocks away, tell of the long walk to the barn to pick up milk and bring it back to their house. Below is the dining room in the Boys' House at Rackliffe Heights.

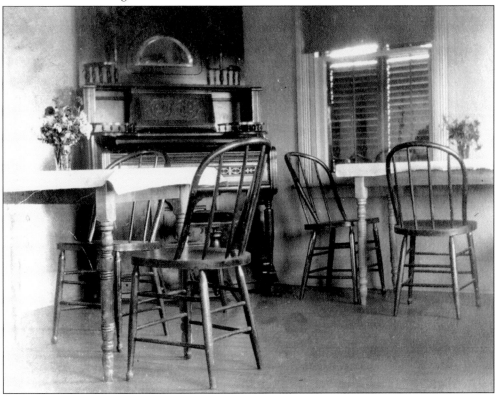

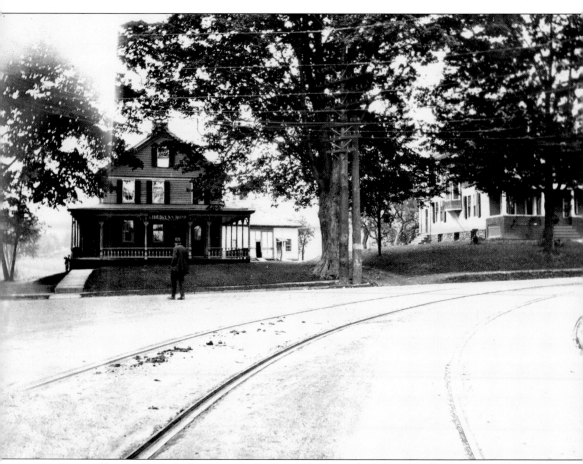

Pictured here is Cooke's Corner, with the Boys' House on the left and trolley tracks visible in the foreground. One Saturday when there was no food for the next day and no money to purchase any, John Klingberg gathered every one together, and they prayed for food. The very same day, the local bartenders' union had a picnic, but because it was cloudy and cold, only a few people came. On the way home from their outing, two men jumped out of the trolley in front of the Children's Home and deposited a large clothes basket of leftover food on the front porch. They quickly boarded the trolley again and left without a word. Klingberg and the children received the food from the bartenders as a picnic from God, an answer to their prayers.

The number of girls was growing at the Burr House, as seen in this photograph of 28 girls and 3 matrons. It was time to start looking for a larger house to accommodate them.

This stately house was purchased for the girls in 1913. It was located next to the Boys' House at Cooke's Corner on Corbin Avenue. This would be the last house for the girls; they would live here for the next nine years.

Tragedy struck John and Magdalene Klingberg's own family in 1914 with the death of their third child, Paul Milton. He was 10 years old and had been ill for a year but was expected to recover. The loss deeply grieved John Klingberg, but he knew it would help him identify with those who were suffering a similar loss. In addition to his parents, Paul left a sister and three brothers.

When the Klingbergs lived at this Garden Street residence in 1916, the following incident occurred. One evening, while John Klingberg was sitting in the living room, the front door was suddenly opened from the outside. A hand was thrust through the opening and a handful of cash was dropped on the floor. The door closed quickly, and the anonymous donor disappeared. Klingberg continued to trust in God for all of his needs, and there are many interesting stories of how those needs were met. One story tells of a stray pig that wandered into a farmer's kitchen in Minnesota. The farmer sold it and donated the proceeds to the Children's Home. Many chicken farmers donated the profits from eggs laid on the Sabbath. Two boys in Michigan sent their wages earned sawing firewood. There were times when the Children's Home would be down to the last penny, and then gifts flooded in.

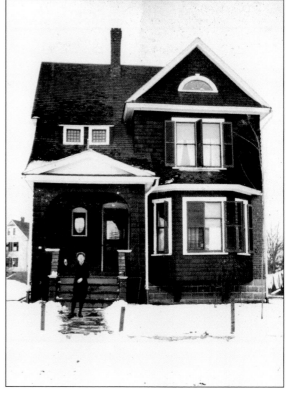

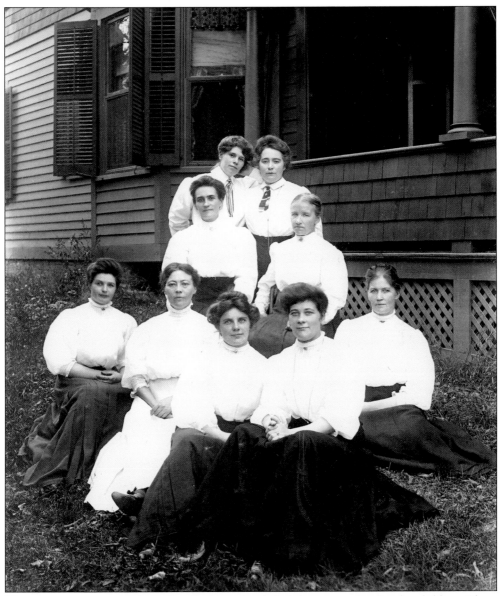

Matrons were very special people who committed their lives to caring for the children. These women gave up much of their lives to become full-time parents to so many boys and girls. Alice Maxon, a matron at the Boys' House, died unexpectedly from complications of the flu. Her obituary paid tribute to her by saying that she "was the only mother, the only real friend that many of the little orphan boys ever knew."

In 1917, the Children's Home advisory board became aware that an epidemic had taken the lives of many people in the city, leaving children orphaned or living with a single parent who could not care for them.

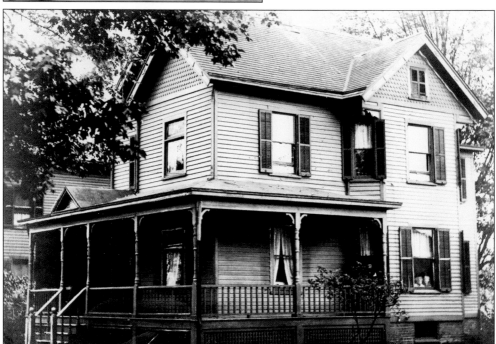

In that same year, the Gallagher House, on the south side of the Boys' and Girls' Houses at Cooke's Corner, was offered for sale. The Children's Home advisory board recommended it be purchased, because of the increasing numbers of young children needing a home following the epidemic.

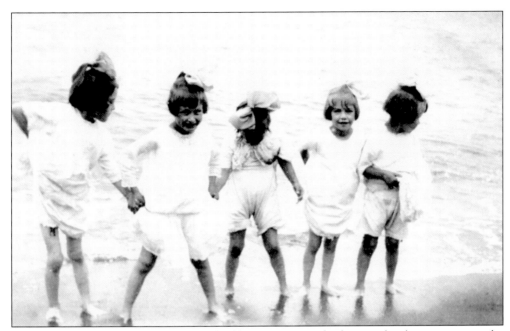

Civic groups in New Britain and Hartford began treating the boys and girls to outings at the beach. In those days, it would take a group of people with many cars to be able to transport a large group of children. In August 1919, the Elks Club of New Britain treated 121 children to a picnic and a day at Momauguin Beach on Long Island Sound. These little girls seem to be enjoying the sand and the waves.

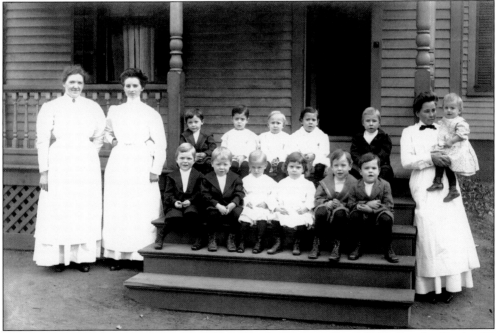

The babies and toddlers were comfortable in their house, but when Mr. Hadley, landlord at 20 South Burritt Street died, the new owners demanded that the house be vacated in the midst of the cold winter weather.

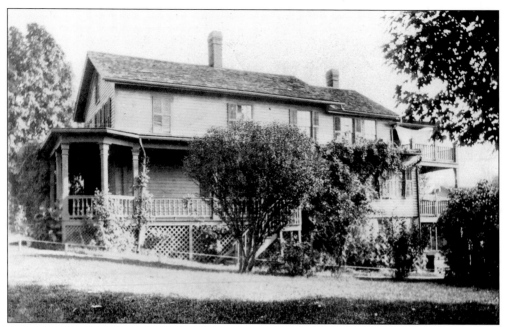

The young children from the Hadley House were moved to this house at 26 Arch Street, near Monroe Street. They did not stay here long, because the landlord doubled the rent. This was an exception to the rule. Most people renting or selling houses or property to John Klingberg treated him with fairness and charity.

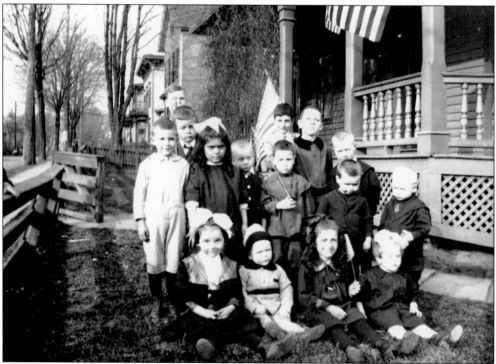

Toddlers and younger children pose in front of the Arch Street House. Arch Street is visible to the far left in this view looking north.

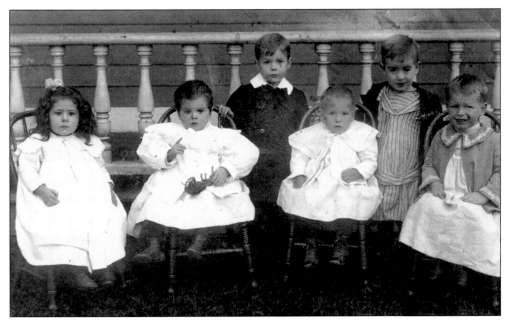

The younger children from the Arch Street House found a new home at the William Hiltbrand house at 20 State Street, next door to the Boys' House at Rackliffe Heights. Hiltbrand would become a long-term staff member at the Children's Home and a favorite of many Children's Home alumni.

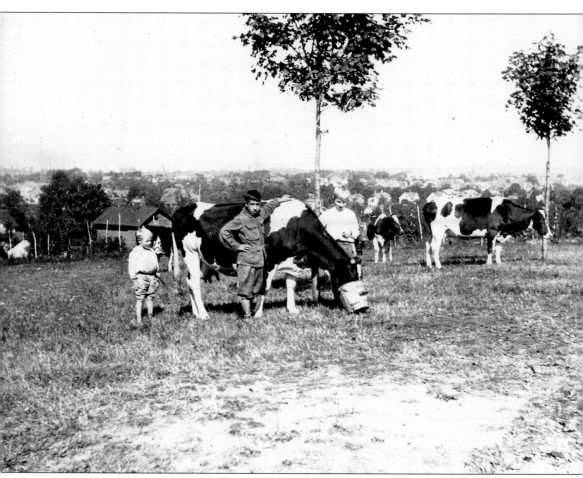

S.F. Avery, a resident of New Britain, advertised in the local newspaper that he had found a heifer on the loose. A man from Kensington, who had a heifer matching the description, claimed it, but one of the Children's Home heifers with the same description had also wandered off. The heifer in question was claimed by the Children's Home as well. The dispute went to court, and Judge J.H. Kirkham heard the case. The boys at the Children's Home identified the cow as one they had fed for months and told the judge of traits particular to it. Then one of the boys turned the heifer loose, and she promptly ran around the barn and into her designated stall. The case was closed.

Two

THE HILLTOP YEARS
1922–1970

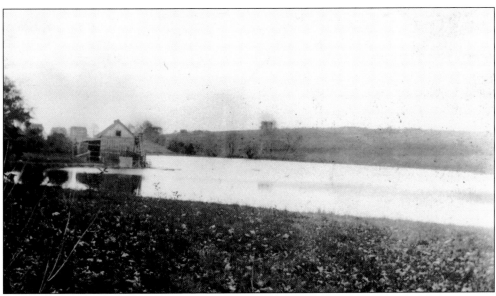

On October 6, 1903, three months after founding the Children's Home, John Klingberg met Charles L. Moore on Church Street in New Britain. Moore said to Klingberg, "I presume that you are going to start a fund for a new building, and if so I shall be glad to give $5 as a beginning." John accepted the offer and deposited the money in a special savings account at the Burritt Savings Bank. At the end of the first year, the building fund had increased to $64.50. By the end of the fourth year, the fund had grown to $1,174.68. Klingberg had been searching for a suitable site for his new Children's Home throughout New Britain. The search ended when he found a hill at the south end of town called Rackliffe Heights. This photograph shows the hill in the background behind Doerr's Pond (now Martha Hart Pond). The hill was barren, except for one house on the top of State Street.

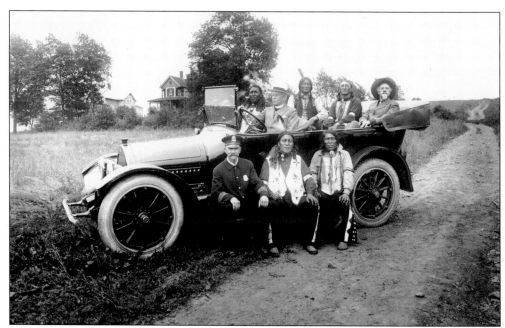

The Rackliffe Heights property was east of Doerr's Pond and ice business. Below the hill to the north was Rentschler's Park, which was used as circus grounds and a recreation area. On its site was a saloon and outdoor bowling alley. This photograph shows Buffalo Bill Cody (seated in the car on the right) visiting the park, with Rackliffe Heights behind him and a path up the hill that would eventually become Linwood Street.

The land on the hilltop was overgrown and rocky farmland, as shown in this view looking north from the top of State Street.

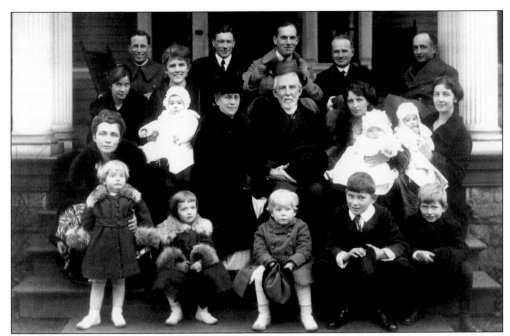

In 1908, a member of a prominent New Britain family, Howard L. Platt (back row, center), called John Klingberg to his home to inquire about the work of the Children's Home. Satisfied that he was doing good and needed work for the community, Platt asked if he had a suitable site for a new building. Upon hearing about the property on Rackliffe Heights, he arranged to meet on the hill with owner Frank E. Rackliffe the next day. (Courtesy of the Local History Room, New Britain Public Library.)

On November 13, 1908, the first three and a half acres was purchased for $1,000. Rackliffe, pictured here, just wanted enough to cover the back taxes on the land. Over the next few years, the Children's Home bought more land on the hill until, in 1914, all 40 acres of Rackliffe Heights had been purchased from the Rackliffe family, for a total of only $20,000. (Courtesy of Dr. Robert Rackliffe.)

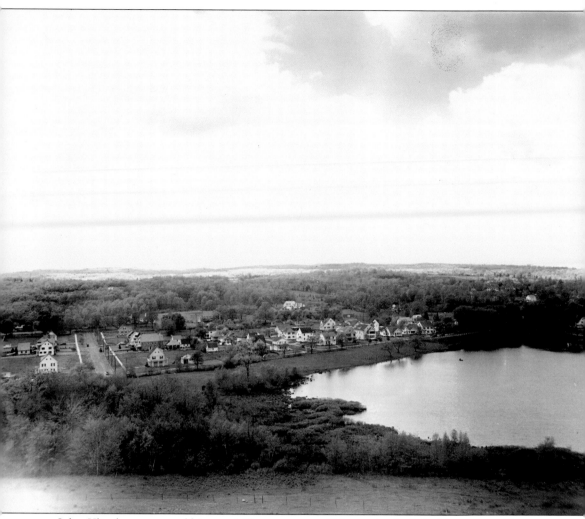

John Klingberg wrote of his new hilltop property, "Mountains in light blue are visible away beyond the Connecticut River, rays from the gold dome of the State Capitol at Hartford meet the eye from the north when the weather is clear, the express trains between New York and Boston can be seen running swiftly through the valley below, and, with the addition of the beauty the City of New Britain gives, especially after dark when the City is illuminated, the

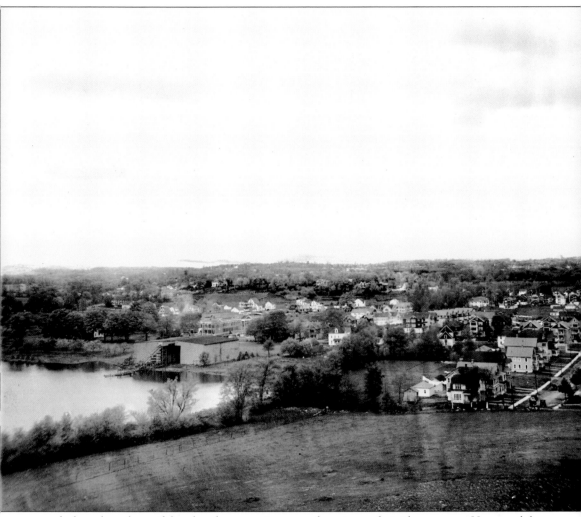

whole makes a beautiful and at the same time ever changing and vivid panorama. How good the dear Lord has been to us. Just think that now, after years of prayer and faith and patient waiting upon Him, He has now been pleased to give a foothold where, should it please Him to help us further, we will be able to erect a building where needy boys and girls can find home, and also serve as a monument of His faithfulness, love and wonderful grace."

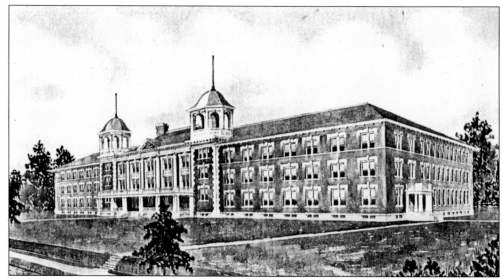

Architect Walter P. Crabtree of New Britain designed a state-of-the-art building with room enough for 300 children and the matrons to live comfortably. The three-story structure was originally planned to include a 344-seat chapel, separate dining rooms for the boys and girls, a swimming pool in the basement, and even a cobbler's room for repairing all the shoes.

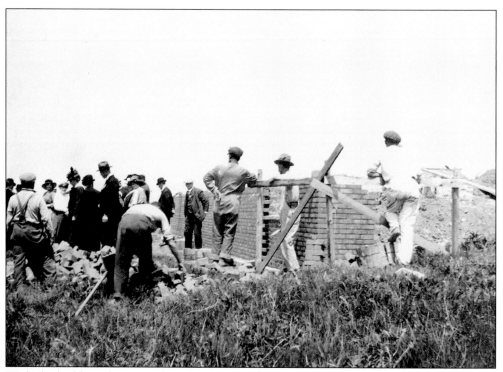

With the building plans complete, the foundation was laid in 1917. Work on the building was finally begun in 1920, after several years' delay because of World War I.

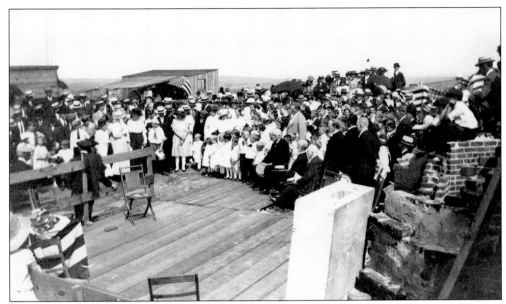

On a warm Sunday afternoon, July 25, 1920, the cornerstone was laid, with several hundred people attending an impressive ceremony. There were many expressions of surprise at the size of John Klingberg's Children's Home.

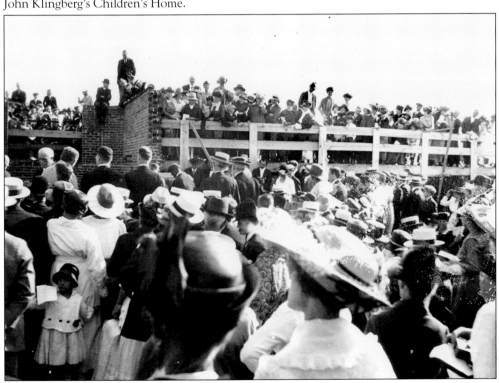

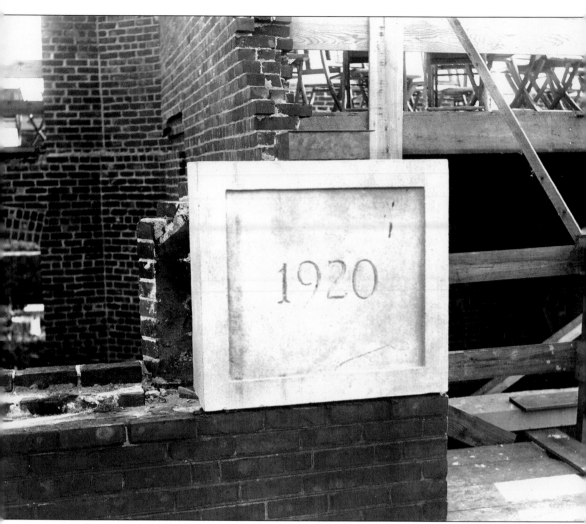

The large cornerstone was set in place and filled with the following items: a Bible, an American flag, a Connecticut state flag, a pamphlet on the Children's Home, a statement of the history and purpose of the Children's Home, a program for the laying of the cornerstone ceremony, and a card from a New York friend. Also included were autographs of the board of trustees members, the architect, building committee members, builders, the New Britain mayor, town clerk, chief of police, judges, ministers, and others. Copies of the following printed materials were also included: the Children's Home articles of incorporation, its rules for the board, the first annual report, the most recent annual report, the first and most recent Children's Home Almanacs, an invitation card, early pictures, a copy of the *New Britain Herald*, a copy of the *New Britain Record*, *Bennett's City Guide*, a copy of the *Hartford Courant*, and several magazines.

New Britain's mayor, Orson F. Curtis, spoke following the placing of the cornerstone. He was applauded loudly by the large crowd in attendance, as he proclaimed that the Children's Home was "more important, from a humane standpoint, than hospitals or fire department." Mayor Curtis said that he felt "no doubt of the success of the work of the Children's Home. . . . It is a work of Christianity and should be encouraged and supported because it is the duty of a community to help further such commendable effort."

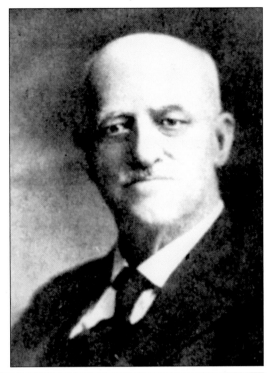

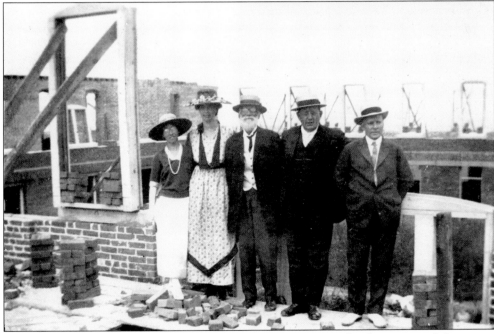

Here Magdalene Klingberg (second from the left) stops to pose for the camera while touring some friends through the construction site. Construction was delayed several times over the years, because of the long duration of World War I. The decision was made to complete only the basement and the first floor, the portion of the building that would meet the needs at that time.

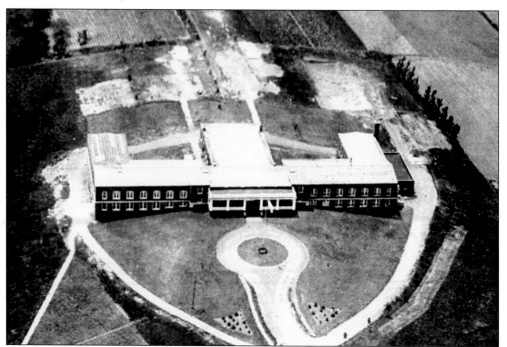

Children living in the various Children's Home houses moved into their new home on a beautiful July day in 1922. One of the Children's Home alumni recalls that exciting day, as the children were instructed to place all their belongings on their beds, gather up the corners of their bedding, and throw it over their shoulders. Then, all together, they sang as they walked from Cooke's Corner, bubbling with excitement, all the way up the hill to what seemed like a spacious palace.

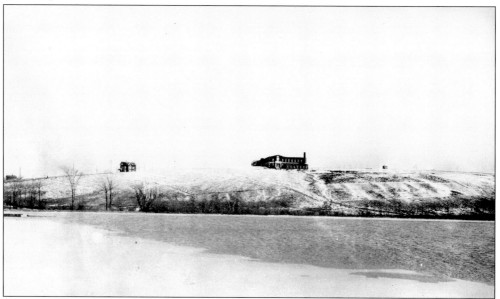

As the children walked down Corbin Avenue and turned the corner on to Shuttle Meadow, this was the view of their new home. Note that there were just two buildings on the hill, and the rest was an open farm field.

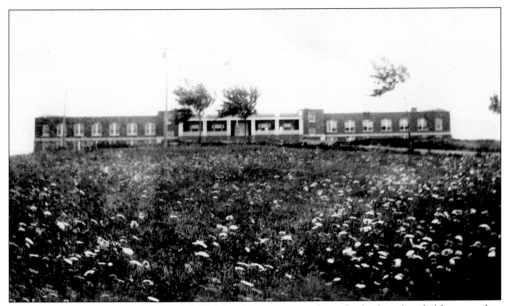

This is how their new and beautiful Children's Home must have looked to the children on that great moving day as they reached the top of the hill.

The new building was referred to by the *New Britain Daily Herald* as the "Building for the Future," in regard to its architecture. Walking through its doors were 140 children, excited to call it their new home.

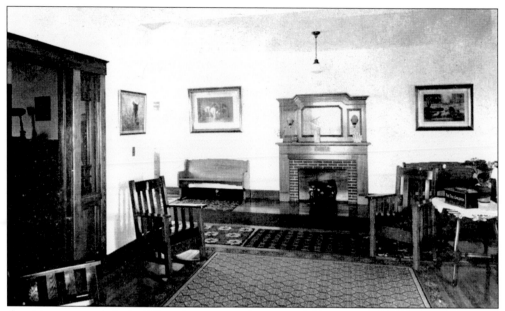

As visitors entered the building, the warm and spacious lobby greeted them. The main office, which was relocated from a downtown building, was off the lobby. Note the donation box on the table to the right. Some of the alumni tell about shaking the box upside down to get the money. After all, it said, "For the Children."

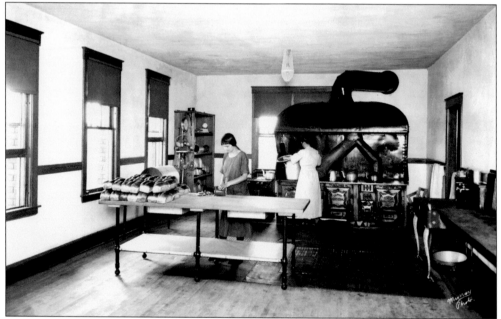

This photograph shows the modern, spacious kitchen with its efficient arrangement and equipment. The stove was state of the art and known as the "household marine stove." It had two fireboxes that provided heat for three ovens, thus saving one-third the amount of coal used in an old single stove. It was capable of baking 20 loaves of bread at a time in each oven. The pantry had built-in cabinets, cupboards, and china closets, a very modern arrangement for that day.

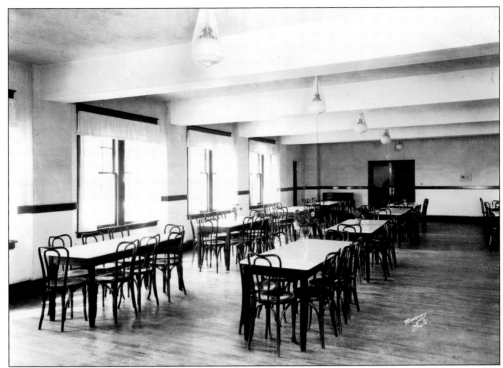

All the children ate together in the new dining room, which was quite a change from the small, crowded dining rooms in the houses. Between this large dining room and the kitchen was a pantry with white enamel sinks for washing dishes.

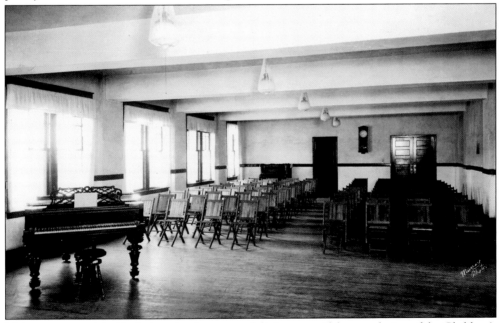

This room was originally designed to be a second dining room if the population of the Children's Home reached 300. Instead, it was made into a chapel and equipped with a piano, a Victrola, and records. It also served as a social hall for large receptions and other events.

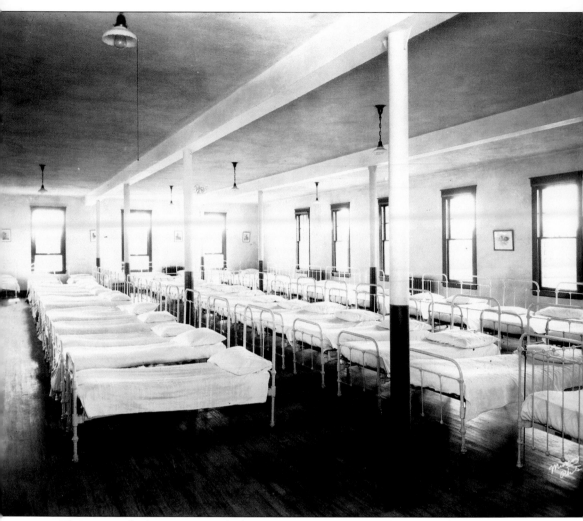

The two new bedrooms, one in the boys' wing and the other at the opposite end of the building for the girls, were large, airy, and bright, with 15 windows on three sides and room for 100 single white enamel beds. These rooms afforded no privacy, but the children had ways of coping. Stories are told by alumni of the activities at night as soon as the lights were turned out. With a matron watching through windows in the doors, they could not fool around where she could see them. Instead, they would pull their pillows under the covers to make it look as if they really were in bed. Then, spreading their bathrobes on the floor, they would lie down on their backs, and by pulling and pushing off from their beds they would slide all over the dorm visiting and playing, safely out of sight of the matron.

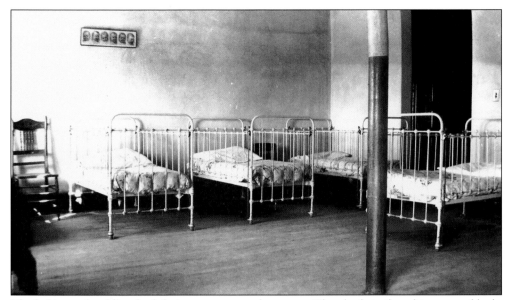

The babies and toddlers had their own room and matrons. They had similar white enamel beds, with sides added.

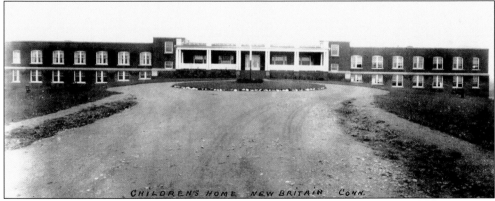

A circular drive of 40 feet was added to the front of the building, around a flowerbed with a flagpole in the center. A driveway was put on each side of the building, and a request was made to the city to make Linwood Street a more passable roadway.

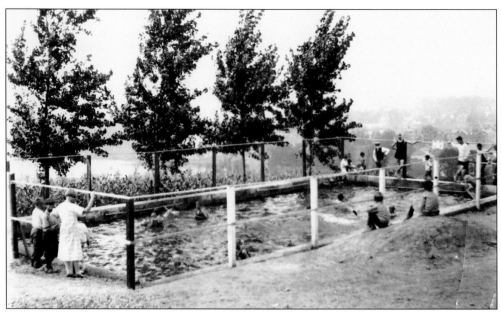

A swimming pool was dug as the result of a "gentlemen's agreement" between John Klingberg and the older boys. The boys would dig the hole 10 by 20 feet, with one end being 3 feet deep and the other being 5 feet deep. In turn, John would have the pool lined with cement after the boys completed their digging. The plan then was to allow the boys to use it one day, and the girls would have access to it the next day.

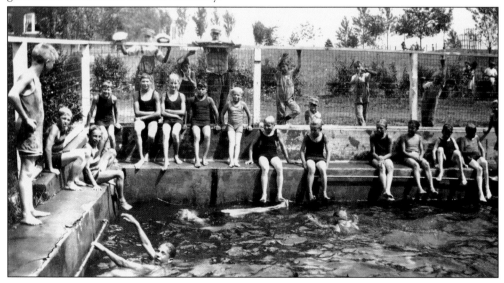

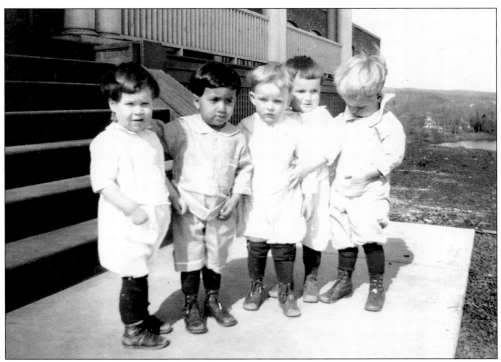

For these young boys, it must have been quite a change to move from the small Hiltbrand House on State Street to a building where the halls were wide and long and the rooms were much bigger. The yard covered 40 acres, and the view stretched for miles in every direction.

This sign hung to the right of the front door. Many Children's Home alumni become emotional when they remember visiting days. It was wonderful to have a visitor, especially family, but the visits were usually not often or long enough. The most difficult memories are those of waiting and hoping for a visitor who never came. Some children waited each visiting day for years and never had any family visit, even though they knew they were out there somewhere.

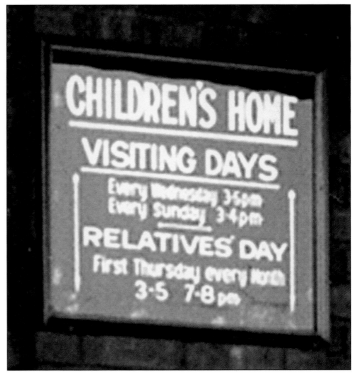

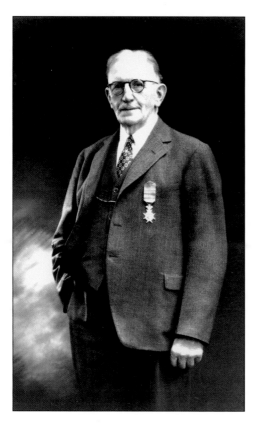

John Klingberg was decorated as a member of the Order of Vasa by King Gustave V of Sweden in May 1928, at the time of the 25th-anniversary celebration of the Children's Home. John was honored for the great work he had been carrying out for a quarter century. In his acceptance speech, he said that if his wife, Magdalene, had been with him, he would have pinned the medal on her because of all the work she had done for the benefit of the orphanage. Magdalene Klingberg was in Sweden at the time, enjoying her first vacation in 25 years.

Here the children gather around John Klingberg, under the American and Swedish flags, as they celebrate the 25th anniversary and his award from King Gustave V of Sweden. John is in the back row, directly under the Swedish flag.

After the work on the hilltop had settled into a routine, John Klingberg's thoughts turned to the many needy children back in Chicago. He and his daughter Mabel, who was already much involved in the Children's Home, went to Chicago to start another home. "Miss Mabel," as she was known affectionately by the children, remained in Chicago to run the new Children's Home when her father returned to New Britain.

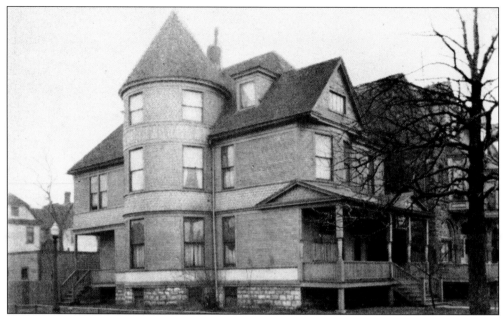

The Chicago Children's Home began in this house on West 63rd Place. It was near a coal yard and the elevated trains, so cleaning out the thick dust that had settled in the house was the first order of business. The home was established with the same values and principles as in New Britain, but the authorities in Chicago were not impressed with the simple establishment of a "children's home" and saw it as an "institution" that needed to be regulated. Nevertheless, the work began in October 1926, and the home exists today as the Sunny Ridge Family Center, now located in Wheaton, Illinois.

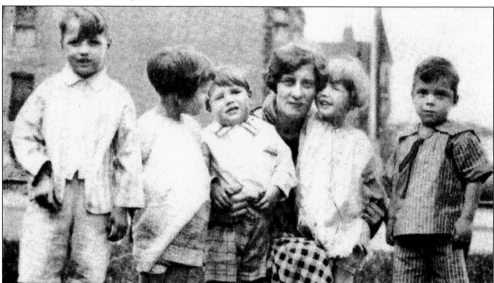

In October 1926, Mabel Klingberg received the first little girl into the new home in Chicago. The next month, a young boy and his three little sisters arrived. Miss Mabel was joined in the work by Anna Gothberg, who eventually took over the Chicago Children's Home when Mabel returned to New Britain in 1936, due to poor health. Pictured here is Miss Mabel with several of the first children.

John Klingberg visited the Chicago Children's Home to see his daughter Mabel and the children whenever he could. Alumni remember gathering around him and sitting on his lap during these visits. He is pictured here with the children beside the original house.

The work at the Children's Home in Chicago continued to expand with a group of happy, active children. The first annual report from Chicago reported that 22 children had been served over the year, that $7,994.47 in donations had been received, and that $235 had been received for the start of a building fund. The report gave special thanks to Rev. Swaney Nelson, pastor of the Swedish Baptist Church of Austin, who acted as the first superintendent while also ministering to his large, active congregation.

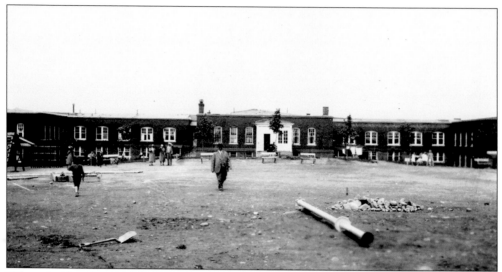

When the New Britain Children's Home building was completed in 1923, the play area behind it remained sand and dirt. A playground was made possible in 1927 through the donations of three New Britain organizations. The Rotary Club made the pool possible; the Lions Club paid for the paving of the play area; and the New Britain Agricultural Society provided swings, slides, horizontal ladders, and park benches.

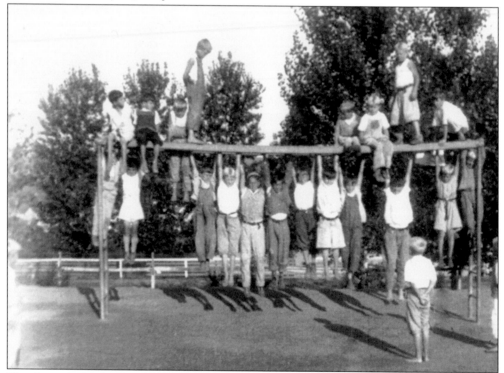

The Agricultural Society, which had been founded by Elihu Burritt, was closed after its 50-year existence. The society decided to give its remaining funds, a sum of $600, to the Children's Home for the playground equipment. The playground was aptly named the Elihu Burritt Memorial Playground.

The Home That Prayer Built

Condensed from The
Kiwanis Magazine

T. E. Murphy

JOHN KLINGBERG has never asked anybody for a cent, yet people have given him nearly $2,000,000 during the last 40 years. Besides money, he receives such gifts as tons of clothing, a carload of potatoes, a fine milch cow and hay to feed her. His mail is an ever-recurring miracle of money streaming to him from the 48 states, averaging $1000 a week.

These happenings are, in his words, "daily dealings with God." Four decades ago, when he was a poor clergyman serving a poor congregation, he resolved to found a home for orphans. Then and there he made a vow that he would never ask anybody for anything, or even tell anyone his needs, but would rely completely on prayer and faith.

He has never broken his resolve. Yet, starting penniless, he has built one of the finest homes for children in the United States. Its buildings, valued at a half million dollars, stand on a beautiful 40-acre estate on the highest hill in New Britain, Conn. And it is wholly free of debt.

The Home is not connected with any church or organization. The nearest thing to sponsorship is the friendly interest of Mr. Klingberg's fellow clergymen of the Swedish Baptist church, who long have watched this demonstration of perfect, childlike faith in prayer, and of course they spread the story.

The only literature Mr. Klingberg distributes is a simple booklet of facts acknowledging even the smallest donations. No names are ever mentioned. "We do not want to receive gifts from people motivated by self-glorification," he decided at the very beginning. So you read such items as "Friends in New Sweden and other towns in Maine have sent us again a carload of potatoes"; "three bushels of turnips and cabbages from Bristol, Conn."; "eleven aprons and four cans of soup from Alcester, S. D." With one gift came the message: "This is the money from the eggs which my hens lay on Sunday."

People are always handing Mr.

49

In 1943, the *Reader's Digest* published an article entitled "The Home That Prayer Built," written by T.E. Murphy and condensed from the *Kiwanis Magazine*. As a result, many people from around the country sent contributions in support of the work of the Children's Home, with notes of encouragement. Numerous people reported having been reassured that God indeed answers prayer. Because the article appeared during World War II, there were many letters from parents who were now praying with greater faith for their sons and daughters overseas, because of John Klingberg's story.

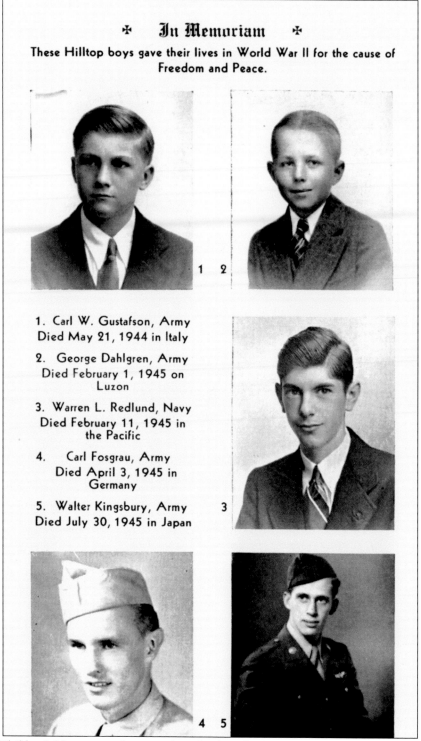

✠ In Memoriam ✠

These Hilltop boys gave their lives in World War II for the cause of Freedom and Peace.

1. Carl W. Gustafson, Army
Died May 21, 1944 in Italy

2. George Dahlgren, Army
Died February 1, 1945 on Luzon

3. Warren L. Redlund, Navy
Died February 11, 1945 in the Pacific

4. Carl Fosgrau, Army
Died April 3, 1945 in Germany

5. Walter Kingsbury, Army
Died July 30, 1945 in Japan

In the Children's Home annual report of 1945, John Klingberg honored these Hilltop boys who had given their lives for their country in World War II.

During the war, a "Mother's Flag" was hung in the foyer of the main building. These red-and-white flags, with blue stars representing each family member serving in the armed forces, were hung in windows across the nation. On the Children's Home flag in January 1944, there were 76 blue stars representing the young men and women from the Children's Home serving in the war. By war's end, five gold stars represented the five men who gave the ultimate sacrifice for their country.

While visiting the World War II Memorial in New Britain's Central Park, Klingberg alumnus David Anderson discovered that his "Children's Home brother," George Dahlgren, who died in action on February 1, 1945, had not been listed on the monument. Anderson worked with the authorities to correct this oversight. They finally did so and etched George Dahlgren's name on the monument. In this photograph taken during their days at the Children's Home, David Anderson is shown in the back row, standing between two of his friends lost in the war, George Dahlgren (left) and Carl Gustafson (right).

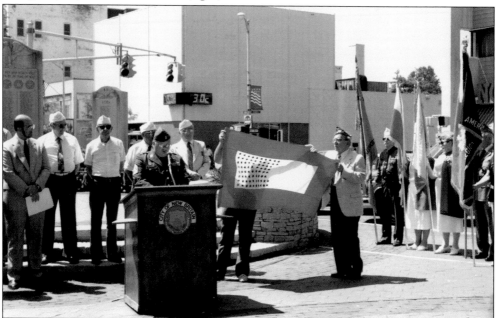

At the New Britain Memorial Day service in 1991, veteran and Klingberg alumnus Richard Margeson spoke of the number of men and women from the Klingberg Children's Home who served in the U.S. armed forces, as he displayed the Children's Home flag.

A biography of John Klingberg, *J.E. Klingberg Adventurer in Faith*, was written by his son and daughter-in-law, the Reverend Robert and Irene Klingberg. Published in 1948, the book tells of John's life of faith and the establishment of the two children's homes in New Britain and Chicago. Information for the biography was gathered from John Klingberg's diaries, notes, and records. The Baptist Conference Press published the book.

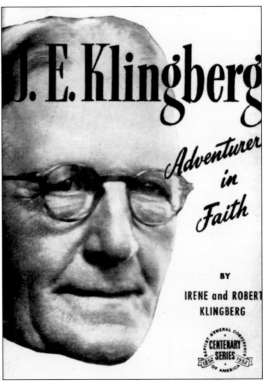

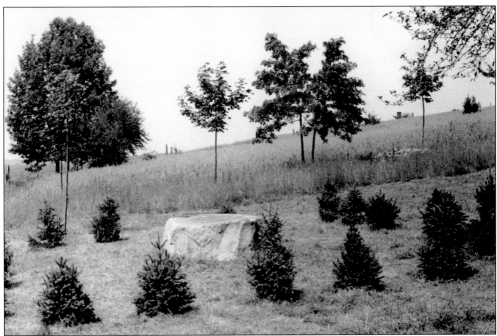

John Klingberg made the following entry in the early 1940s in his diary: "Many years ago I began to go to a certain place in Barnesdale where there was a rock with a flat top. The great boulder lay under a high cedar. I found it once as I walked through the woods. And because it was suited to my purpose, I often returned to this spot to pray to my Heavenly Father."

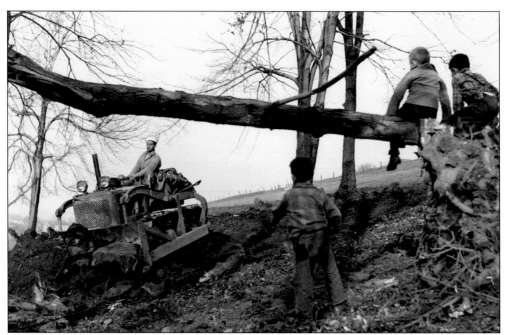

In 1945, the Prayer Rock was moved to its present location on the hilltop campus by John Klingberg's close friend and supporter, Angelo Tomasso Sr. In this photograph, the seven-ton Prayer Rock is being pushed into place with a Tomasso bulldozer while some of the boys watch.

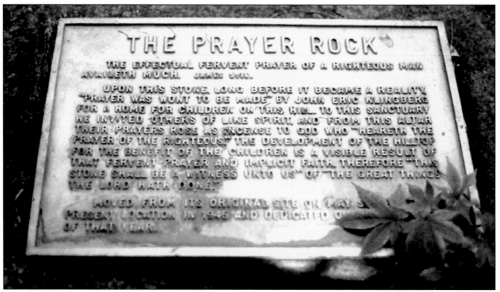

A plaque was mounted on the Prayer Rock with the following inscription: "The effectual fervent prayer of a righteous man availeth much. James 5:16. Upon this stone, long before it became a reality, 'Prayer was wont to be made' by John Eric Klingberg for a home for children on this hill. To this sanctuary he invited others of like spirit, and from this altar their prayers rose as incense to God who 'heareth the prayer of the righteous.' The development of the hilltop for the benefit of the children is a visible result of that fervent prayer and implicit faith. Therefore 'This stone shall be a witness unto us' of 'the great things the Lord hath done.' "

Since its placement on the hilltop campus in 1945, various events have been held at the Prayer Rock. Many visitors have come to pray, to read its inscription, and to remember a great man of faith and his faithful God.

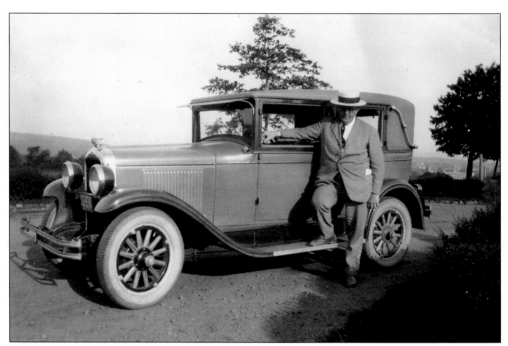

John Klingberg did not fit the stereotypical image of a Baptist preacher in the early 20th century. He had good friends in all the churches, Protestant and Catholic, and was counted as a friend in the synagogues. He loved his cars and had a reputation for driving fast. In the above photograph, he is seen on the hilltop with one of his automobiles. Below, he poses in the backyard of his Garden Street home with his Indian motorcycle.

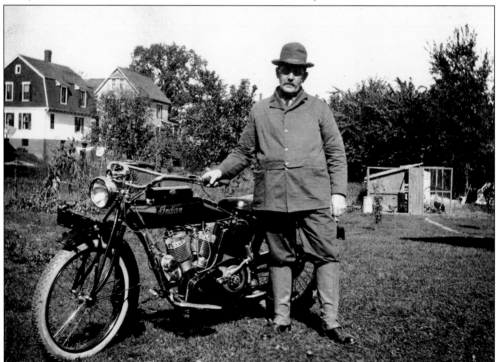

On June 6, 1946, John Klingberg collapsed and died while walking on Asylum Street in Hartford. He was 78 years old. Word of his death spread throughout the country. Many expressions of sympathy and tribute were sent, in recognition of the man whose faith and work accomplished so much for so many children for more than 40 years.

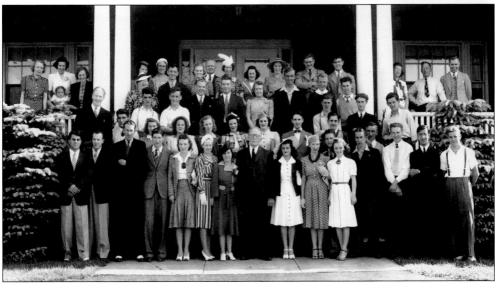

At a memorial service in Chicago, Rev. Bruce Fleming, speaking for his fellow alumni of the Children's Home, paraphrased a quotation from Winston Churchill: "Never have so many of us owed so much to one man." He went on to point out, "Dr. Klingberg never sought any greatness for himself. He was the first one to direct all the praise for what he had accomplished to God, who made it all possible." In this photograph, John Klingberg is standing with more than 50 Children's Home New Britain alumni, on the front stairs of the New Britain Children's Home in 1944.

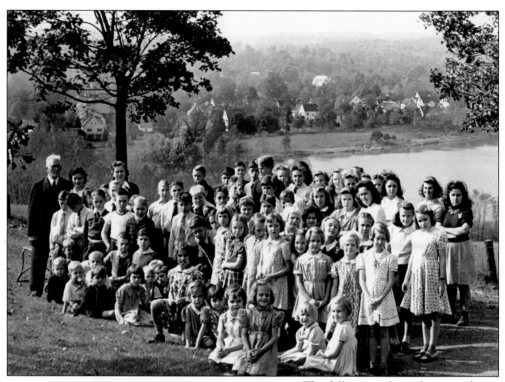

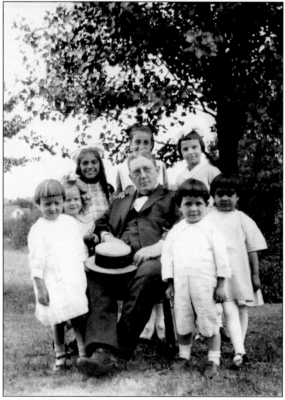

The following editorial appeared in the *New Britain Herald* upon the death of John Klingberg: "It is impossible to speak with too many lavish words of such a man. One need think only of the influence he exerted in the lives of the hundreds of the young, who came to his benign attention during the years; in the end to develop into good citizens and Christian men and women—all this and much more were among the achievements of this prince of good works during his more than 40 years of activity in a difficult field. The founder of the home for the once homeless is gone. But his endeavors in loving-kindness will continue. The imposing structure on Rackliffe Heights, overlooking the city and seen from many parts of it, will carry on in the future as in the past. It is an enduring monument to the man who has just died, one which will leave an impression of good will and charity upon the city, and indeed, all of Connecticut."

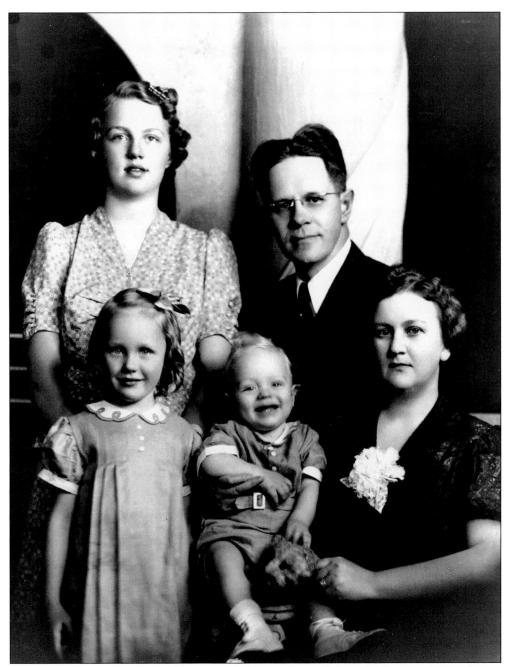

Rev. Haddon Klingberg Sr., eldest son of John and Magdalene, had pastored churches in Davenport and Sioux City, Iowa, and Kansas City, Missouri, before returning to New Britain in 1943 to assist his father in running the Children's Home. Upon his father's death, Haddon Klingberg became director. Here he is pictured with his wife, Myrtle, also from New Britain, who played a key role in his administration of the Children's Home, and their children Carolyn, Norene, and Haddon Jr.

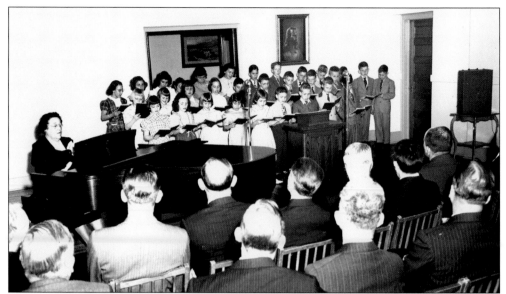

For two years, various memorial gifts to the Children's Home were combined into a fund to purchase this piano. The inscription reads, "Given in memory of 131 friends whose names are inscribed in the hearts of those who loved them most, April 2, 1950." The occasion pictured here is the piano dedication concert, featuring the children of the Children's Home and Elsa Swenson at the piano.

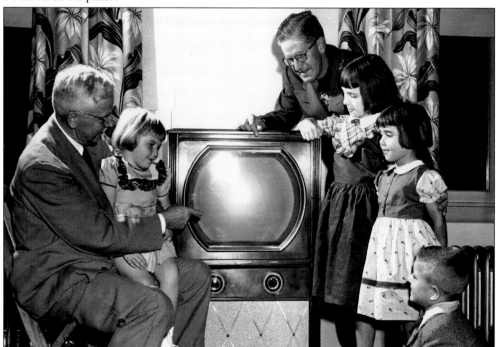

The Hartford Exchange Club donated a new television to the Children's Home on October 7, 1950. President R.V. Thomson and chairman Wilson G. Barainerd are explaining how television works to four delighted children. The generosity enjoyed by John Klingberg continued on to the next generation.

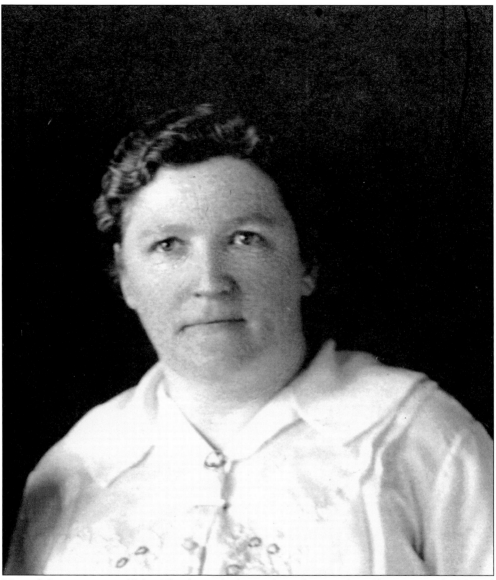

Hannah Larson, sister of John Klingberg, died in 1950 at the age of 82. She came to the United States c. 1910 to work alongside her brother in caring for the children. Many Children's Home alumni who were in Hannah Larson's care have reported, "I was Miss Larson's favorite." What a wonderful legacy—to have left so many children feeling like her special favorite.

Through the 1950s, the New Britain Lions Club maintained a woodshop for the Children's Home boys. They purchased more than $3,000 worth of woodworking equipment and then, under the leadership of Max Kirshnit, spent every Tuesday from 7:00 to 9:00 p.m. working in the shop with the boys. In 1955, the boys made 50 wooden trays for use by the patients at the New Britain Memorial Hospital, now the Hospital for Special Care.

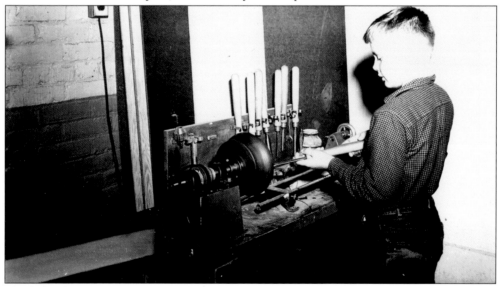

The lathe this youngster is using was also given to the Children's Home by the New Britain Lions Club. A former president of the club and president of Universal Manufacturing Company of New Britain made and adapted the machine for safe use by the boys.

The Children's Home boys presented a new
gavel to the New Britain Lions Club as a
thank-you gift for equipping and running the
woodshop program.

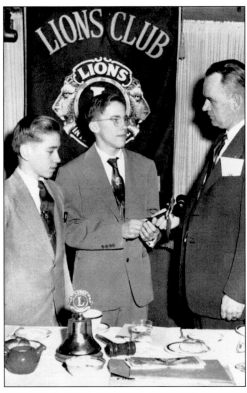

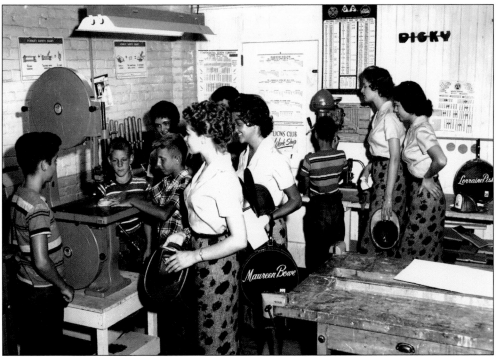

The boys shown here are proudly giving a tour and demonstrating some of the power tools in
the Children's Home woodshop.

John Edwin Klingberg was the youngest son of John and Magdalene, and he, like his sister Mabel, worked at the Children's Home most of his life. He was best known as "Eddie the Cook." He suffered with bouts of depression, but when they lifted he was witty and fun to be with. Eddie was a tireless worker and had great compassion and love for the children and those less fortunate.

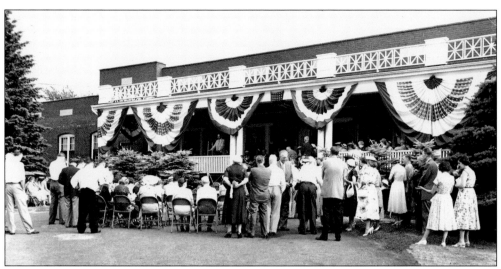

The 50th anniversary of the Children's Home was celebrated at two locations in 1953. The first was at Vance School, where many congratulatory speeches were made and the children entertained the attendees with songs. The second location, seen here, was the front lawn of the Children's Home. Rev. Bruce Fleming, a Children's Home alumnus, gave the keynote address, which he had titled "Impressions of Life." Greetings were brought by Eric C. Boheman, the Swedish ambassador, and Arthur J. Anderson of the Swedish Consulate in Boston.

Following the dedication of the 50th-anniversary gateway at the front of the Children's Home, special guests posed for this picture. They are, from left to right, George Carlson and Arthur Carlson, two of the first three orphans who found a home with the Klingbergs; Rev. Haddon Klingberg; Bessie (Boyle) Finnigan, the first female orphan; Eric C. Boheman; and Arthur J. Anderson.

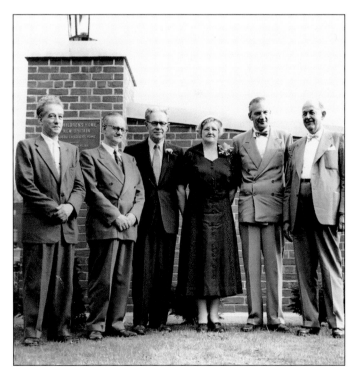

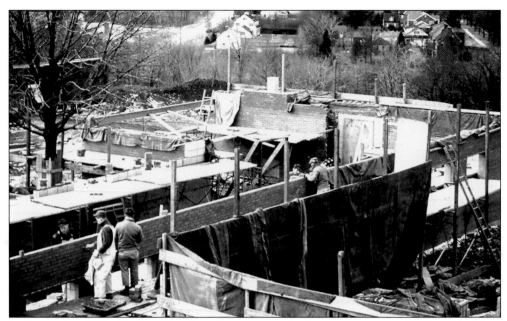

In September 1955, Haddon Klingberg Sr. announced plans to construct a $175,000 building that would serve as living quarters for 20 younger children and also house an infirmary. The new structure would be connected to the existing building by way of an underground tunnel.

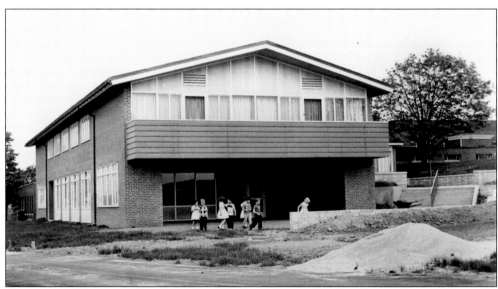

The new wing, two years under construction, was completed and dedicated on May 26, 1957. On the second floor were four bright and sunny dormitory rooms. A small kitchen, a dining room, and a playroom for younger children occupied the first floor.

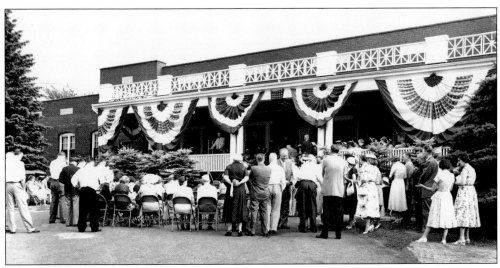

The 50th anniversary of the Children's Home was celebrated at two locations in 1953. The first was at Vance School, where many congratulatory speeches were made and the children entertained the attendees with songs. The second location, seen here, was the front lawn of the Children's Home. Rev. Bruce Fleming, a Children's Home alumnus, gave the keynote address, which he had titled "Impressions of Life." Greetings were brought by Eric C. Boheman, the Swedish ambassador, and Arthur J. Anderson of the Swedish Consulate in Boston.

Following the dedication of the 50th-anniversary gateway at the front of the Children's Home, special guests posed for this picture. They are, from left to right, George Carlson and Arthur Carlson, two of the first three orphans who found a home with the Klingbergs; Rev. Haddon Klingberg; Bessie (Boyle) Finnigan, the first female orphan; Eric C. Boheman; and Arthur J. Anderson.

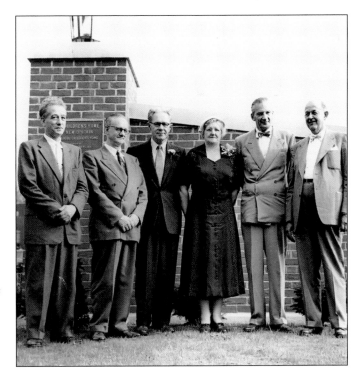

In September 1955, Haddon Klingberg Sr. announced plans to construct a $175,000 building that would serve as living quarters for 20 younger children and also house an infirmary. The new structure would be connected to the existing building by way of an underground tunnel.

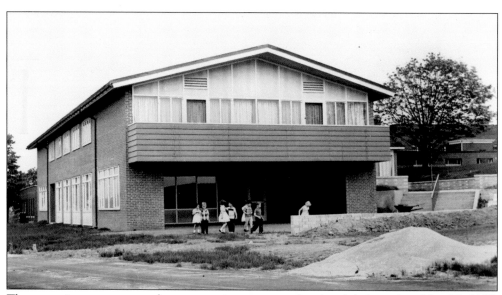

The new wing, two years under construction, was completed and dedicated on May 26, 1957. On the second floor were four bright and sunny dormitory rooms. A small kitchen, a dining room, and a playroom for younger children occupied the first floor.

The infirmary had two bedrooms where a child could be isolated from the other children to prevent the spread of illness. A nurse's night room was located near the infirmary rooms so that children could have proper care 24 hours a day. The Connecticut American Legion Auxiliary contributed funds to furnish the medical room. The nurse in the photograph below is Ione Peterson, and the doctor who oversaw the program was Dr. Robert L. Rackliffe.

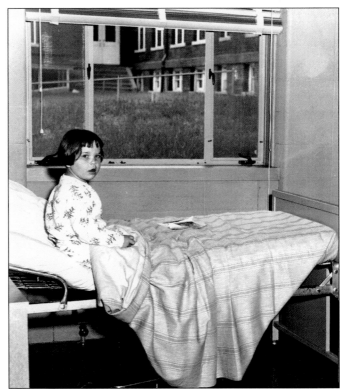

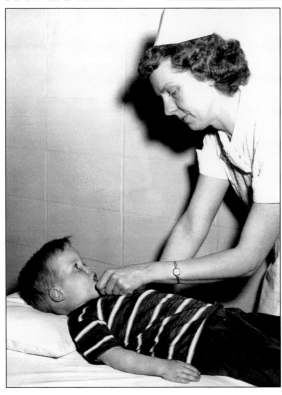

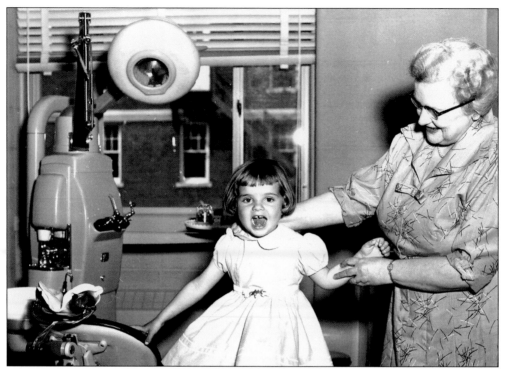

Myrtle Klingberg and this very willing patient are showing off the fully equipped dental office, with drills, water fountain, and X-ray machine. Dr. William J. Morrissey provided regular dental care for the children.

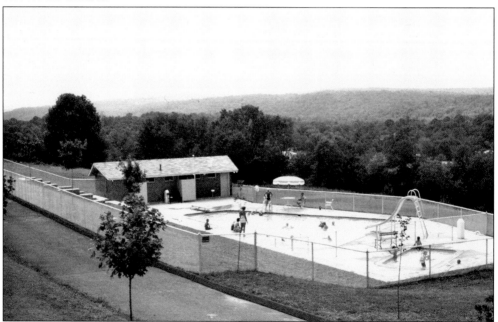

A new swimming pool was completed in 1962. It was a modern and interesting shape and included a slide, diving board, and underwater lights for night swimming. Younger children enjoyed their own wading pool.

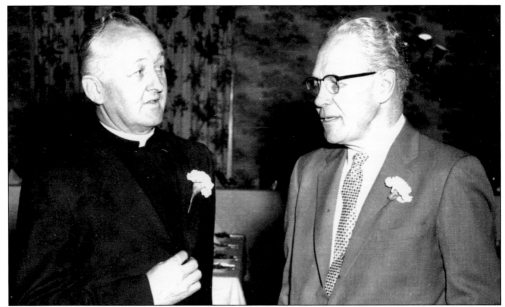

Haddon Klingberg Sr. was named the New Britain Press Club's Man of the Year in 1958. Rev. John J. Pitrus, chaplain of the Polish Orphanage of New Britain, stands with Reverend Klingberg in this photograph. He was a co-recipient of the award. It was presented to them for what they "had done for children in the community, particularly children in need of a home and care."

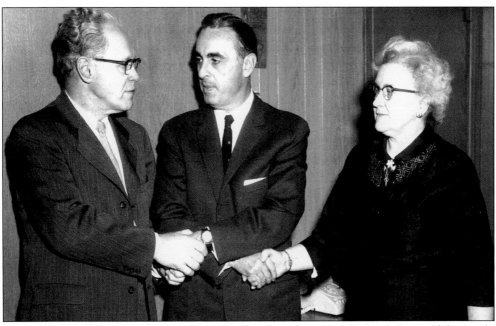

Gov. Abraham Ribicoff said of Haddon Klingberg's and Reverend Pitrus's Press Club awards, "These are the most worthy recipients. The work that the Rev. Mr. Klingberg and Father Pitrus have done for the cause of children is of inestimable worth to the community. As a former recipient of the New Britain Press Club Award, I am very proud to be in their company." Governor Ribicoff is pictured here with Haddon and Myrtle during a visit to the Children's Home.

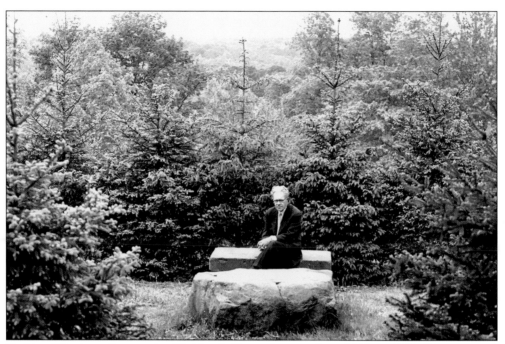

Haddon Klingberg Sr. was the Children's Home director from 1946 to 1968. He continued the work that his father began, but there were mounting pressures from state officials to deinstitutionalize programs for children. In 1968, he retired from his position as director.

During his retirement, Haddon Klingberg Sr. was able to involve himself where needed. He is seen here having a good time with Ponni Urbanska, who served as a much loved cook at the Children's Home for many years.

In 1968, Dr. Haddon Klingberg Jr. (known as 'Don) was appointed director of the Children's Home, becoming the third-generation Klingberg to lead the institution. 'Don, like his grandfather, was a visionary. He led the agency in changes that were very progressive in his day, with the needs of children as the highest priority.

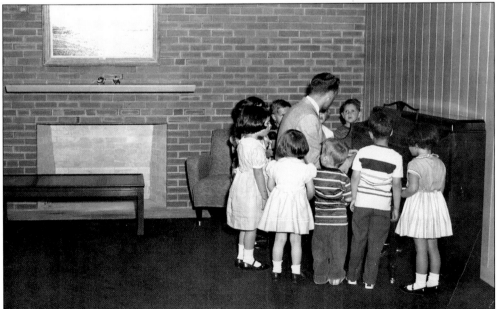

'Don Klingberg had grown up around the Children's Home and thus had a unique perspective of what life was like for the kids. This insight helped shape the changes that he implemented. This photograph shows 'Don entertaining young children on the piano at an open house in 1957.

'Don Klingberg and his grandfather believed that every child needs a family. John Klingberg began his Children's Home to provide children with that family. 'Don began the transition, 65 years later, from orphanage for children without family to treatment facility with programs designed to restore families to children. The name "Children's Home" was no longer appropriate, so the board of trustees adopted the name "Klingberg Child and Family Center," which was later shortened to "Klingberg Family Centers," as it remains today.

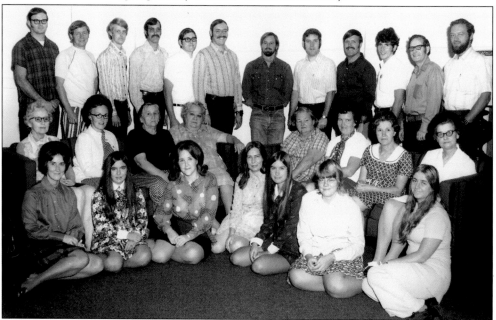

Instead of matrons living with and caring for the children 24 hours a day, a change was made to a professional staff that was trained to work with troubled and troublesome children. The staff worked 40 hours per week and lived at home with their own families. This group staff picture was taken in 1972. 'Don Klingberg is in the back row on the far right.

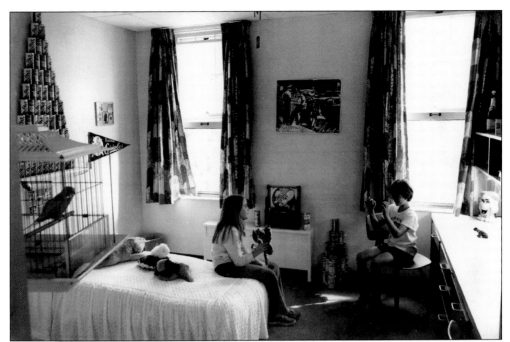

The large dormitory rooms with 50 or more beds were divided into semiprivate bedrooms with closets, individual desks and drawers, and places to hang pictures. Children had their own personal space.

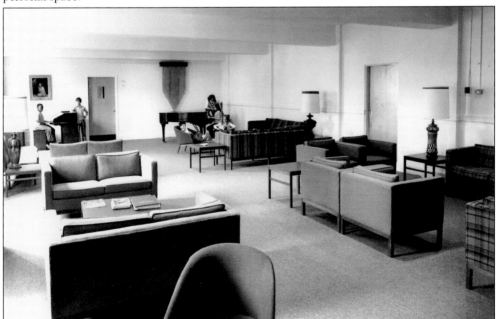

The common areas throughout the building were redecorated to become less institutional and more family friendly. The tan-and-gray walls were repainted in bright colors, and carpeting was used to cover concrete and painted wooden floors. The chapel-auditorium shown here became a lounge with carpeting and groups of soft chairs, a welcoming place for staff and family members to visit with the children.

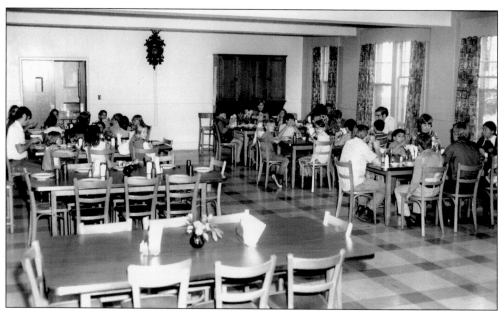

Mealtime was also updated. The development of a food service program brought a greater variety of meals, and children ate family-style rather than being given a plate already prepared for them. Staff joined the children at the tables to make mealtime more homelike.

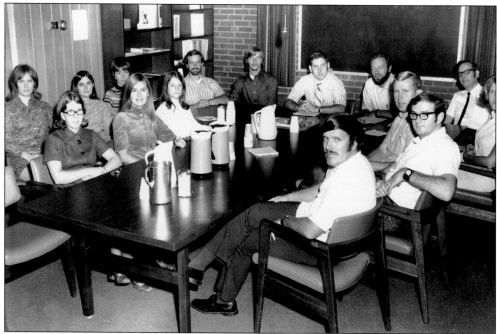

The children who were living at the Children's Home during its transition into Klingberg Family Centers became the first clients in the new program. With help from the new staff pictured here, they either moved back home with families or to foster homes. As new children entered, they were assigned a treatment team that assessed their individual needs and determined a plan to help restore them to their families. The orphanage days were over, and a new day of family restoration had begun.

Three

LIFE AS A HOME KID

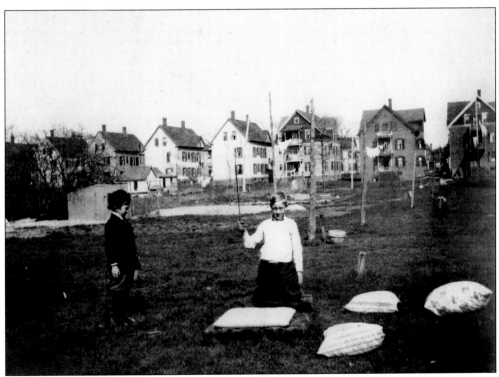

For all of the children living in the Children's Home, doing chores was a necessary part of everyday life. John Klingberg believed that every child should have work to do, tasks fitting with their age and ability, that would benefit the whole group and would make each child feel like a contributing member of the Children's Home family. Pictured here at one of the early houses are two young boys responsible for beating the pillows.

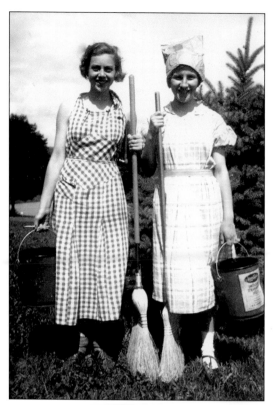

Keeping the interior of the building clean was a Children's Home priority. For instance, the linoleum in the front hall was polished to a high gloss with bowling alley wax. Most of this responsibility was given to the girls, and the boys were assigned kitchen and farm chores.

In the early years, the older children did most of the laundry. These two girls are finding some enjoyment working together.

Imagine the number of socks in a home with more than 100 children. Sorting and matching socks was a major chore, an undesirable one at that, so much so that it became a punishment. The greater the "crime," the more time one spent in the sock-sorting room searching for pairs.

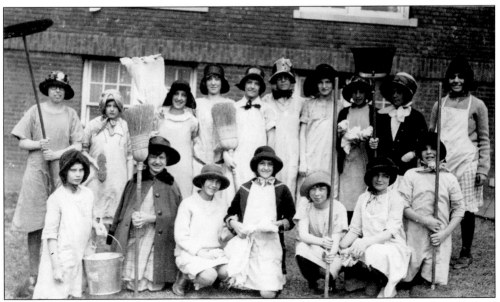

Work is always easier if it is shared with a good measure of fun thrown in. These girls got dressed up for the occasion and, with all the necessary equipment, were ready to clean.

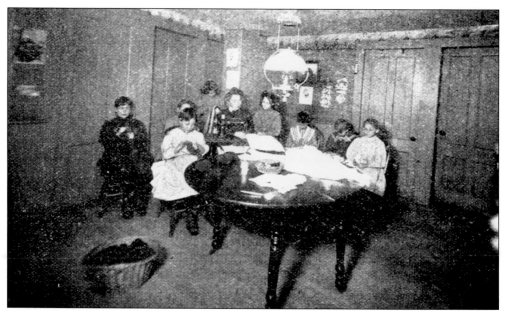

Every child learned to sew and darn so that they could mend their own clothes when they were out on their own. Here is a group of girls in the Sherman House in 1904, sewing together. Alumni tell stories of darning socks so many times that there was hardly any sock left.

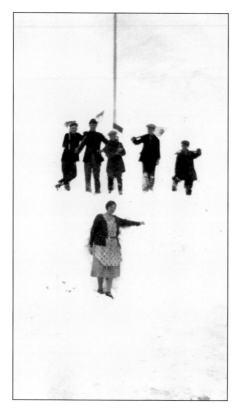

Special chores, such as shoveling after a major snowstorm, demanded extra effort. The hardy boys in this photograph have finished shoveling snow at the front entrance of the Children's Home and at the flagpole on the hilltop. A matron stands in front to show how high the snow is piled.

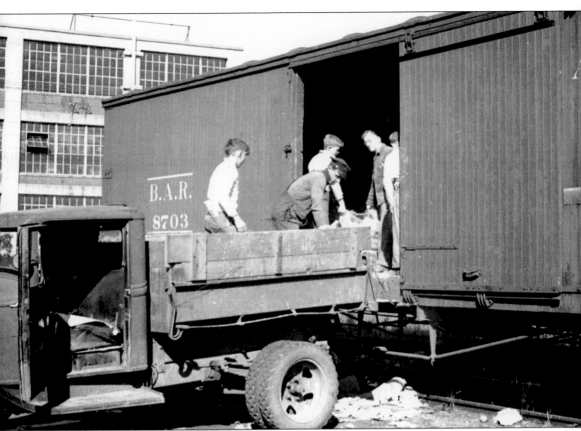

Another occasion calling for extra effort was the arrival of tons of donated potatoes from Aroostook County in Maine. For more than 40 years, potato farmers in New Sweden, Stockholm, and surrounding communities in Maine would fill a boxcar (and, later, a trailer truck) with potatoes for the Children's Home. In 1950, a large trailer truck was on its way south to the Children's Home with Maine potatoes, when it was stopped at the Connecticut state line because it was overloaded. The driver thought he was about to be arrested when the policeman saw the sign on the side of the truck: "This truck load of Aroostook potatoes donated to Klingberg's Children's Home by friends in and around New Sweden and Stockholm." He let the driver continue without so much as giving him a ticket.

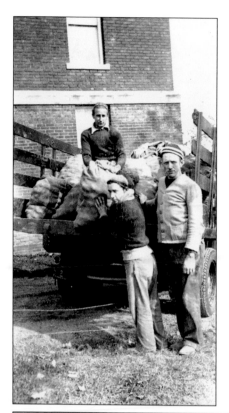

The railroad boxcar with Maine potatoes was parked at a crossing in downtown New Britain, where Children's Home staff and boys unloaded them into a truck. They drove the truck to the Children's Home and filled the potato cellar, which they had built into the east side of the hill. It would store enough potatoes and other vegetables, donated and grown on the hill, to last through the winter months until fresh crops were ready to be harvested the next fall.

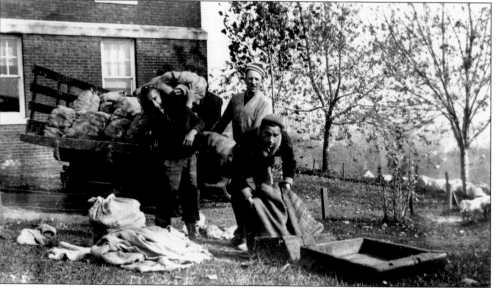

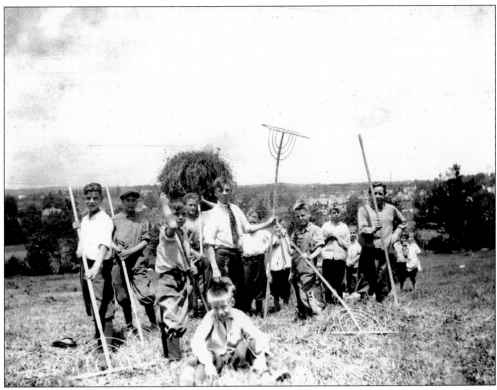

To work a 40-acre farm without tractors and other modern farm machinery took many hands and long hours. In the early years on the hill, the Children's Home was dependent on the farm for milk, eggs, and vegetables from the gardens. These photographs show the boys in the field with hay rakes. Others are getting ready to fork the hay into the hayloft.

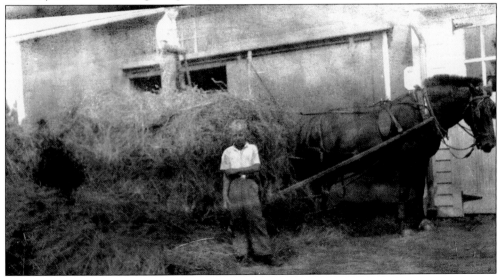

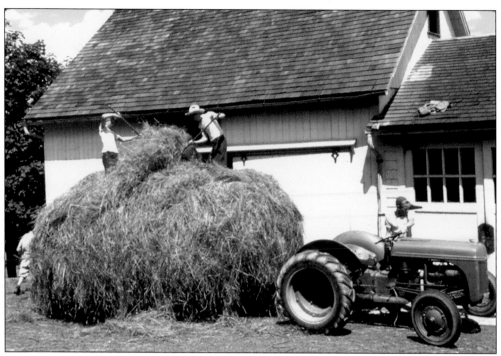

When the horse was replaced with the first tractor in the early 1940s, it was a great day for the Children's Home staff and the farm boys. The numerous hay rakes and forks were stored away and replaced by a large rake and a baling machine, which were pulled behind the tractor.

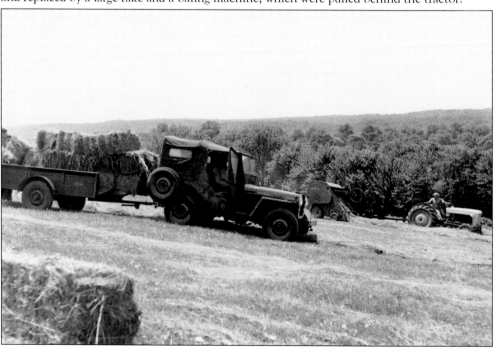

When a boy in the Children's Home reached a certain age and showed interest and ability, he became a "barn boy," a position with status. The barn boys would rise early in the morning, go to a special closet for barn clothes, get dressed, and go to the barn to begin their chores. Barn boy alumni have said that two of the benefits they enjoyed were having some independence from the usual group life and being exempt from morning chapel.

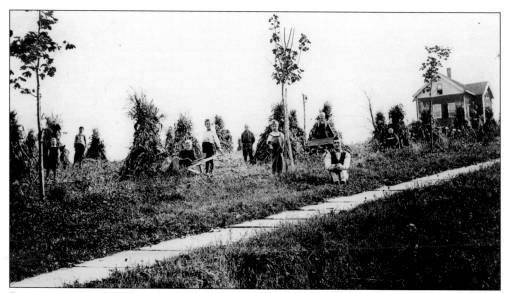

Farming on the Children's Home hill was difficult. The land was unused and undesirable farmland when John Klingberg purchased it. A planning map c. 1910 shows that if he had not bought it, the hill would have become a housing development to be called Rackliffe Heights, with many roads crossing the hill. Every pasture and garden was on a slope. It used to be said that the Klingberg cows had longer legs on one side so they could stand up straight in the hilly pastures. Pictured here is a cornfield to the east of what is now Linwood Street, which was just a sidewalk then.

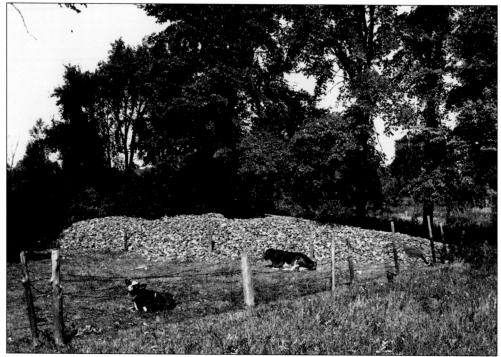

Behind the contented cows in this photograph is a huge pile of rocks removed by hand from the gardens.

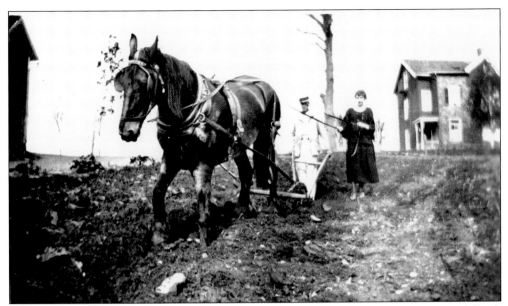

Because of the rocky soil, plowing, especially with a horse-drawn plow, must have been difficult and could prove impossible in some places. Above, Oscar Johnson and Mabel Klingberg work together to plow a garden between the barn and State Street. The photograph below was taken a few years later when the Children's Home had a larger horse.

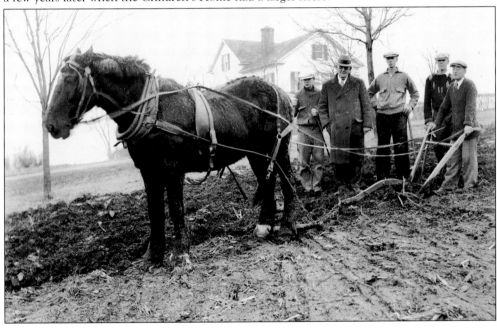

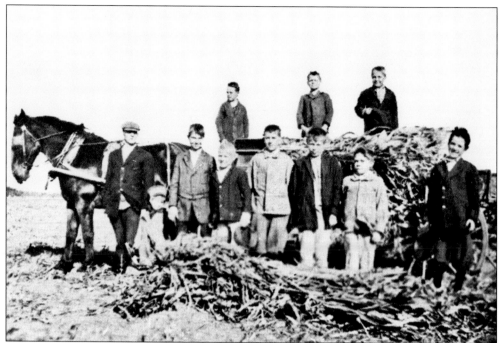

Harvesting the cow corn was another major chore at the Children's Home farm. These two photographs show the early years of harvesting with many hands and transporting the corn to the barn by horse and wagon. In both of these photographs, as in many others of the children working, they seem to be creating some fun for themselves while getting the job done. This is one of the benefits of living with so many brothers and sisters.

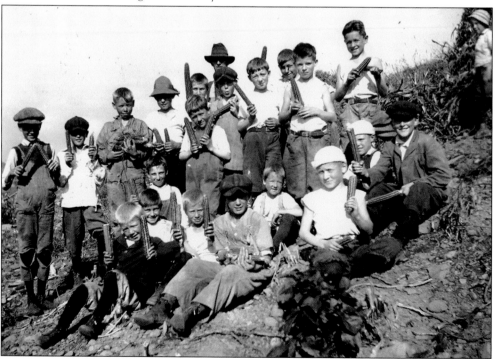

Although a tractor and other farm machinery were making farm work easier, the Children's Home kept a horse until the early 1970s, by which time all the animals were gone. Here, boys pose in front of the machine that chopped the corn and put it in the silo.

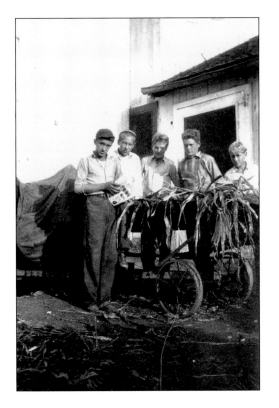

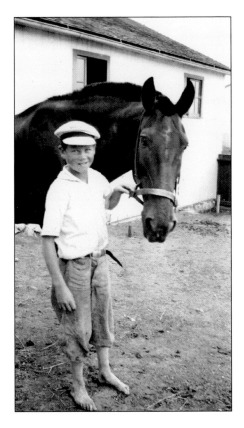

One of the barn boys shows off the workhorse.

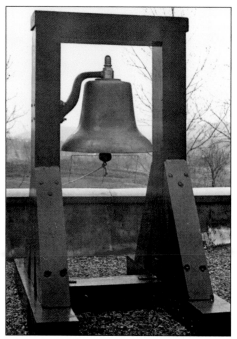

A large bell, weighing 200 pounds, was mounted on the roof above the kitchen and used to call children from the playground and the fields for mealtimes. It could be heard, they say, well beyond the hill on windless days. In 1944, the bell in the photograph to the left was donated in memory of one of the first girls received into the house on Ozone Heights in 1903, by her sister.

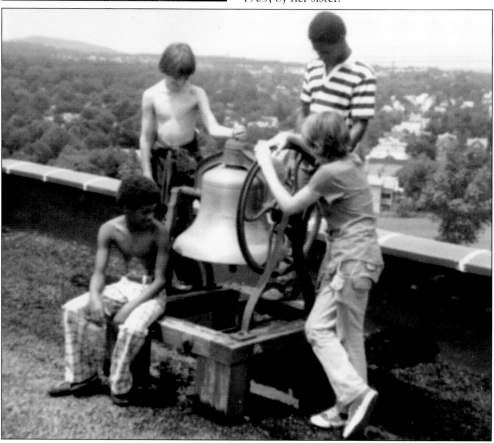

The photograph to the right shows a birthday party at the Hadley House for one of the toddlers. For many children at the Children's Home, birthdays caused a mix of emotions. There was the excitement of having your own special day, a rare occasion in orphan life. On the other hand, one alumna recalled, when she was elderly, that even though everything she needed was provided, the one thing that she wanted most on her birthday was for someone to hug her and love her as their special little girl. When all the children moved to the hilltop, they followed a tradition of putting gifts under the birthday child's chair, as seen in the photograph below.

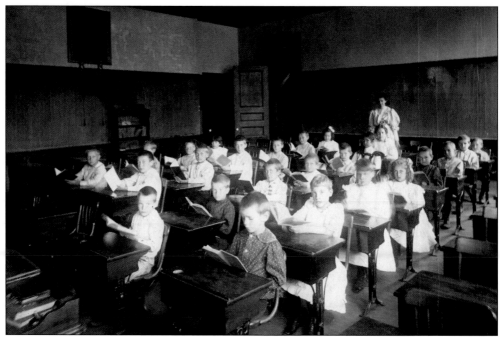

All children from the Children's Home were educated in the New Britain public schools. This photograph of a public school classroom from the early 1900s includes children from the houses at Cooke's Corner.

When the Children's Home moved from the houses to the hilltop, the children attended the Robert J. Vance School. It had been John Klingberg's desire since the beginning to have his own school. He was concerned about overcrowding in the public schools, due to the numbers of children he was enrolling in them, and with having to quarantine all of his children if one of them had a contagious illness. He also wanted the Children's Home students to attend school through the summer.

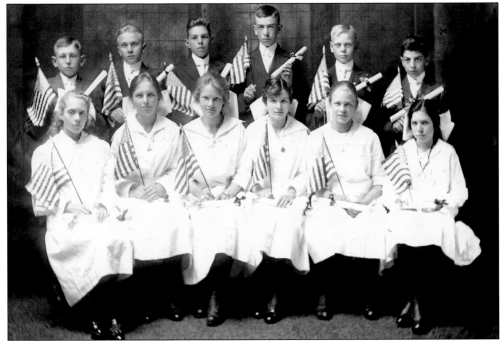

Education was a priority for John Klingberg, who made sure that all the children were educated according to their abilities and interests. Early on, he set up a scholarship fund for those who aspired to go to college or into nursing training. Shown here is a grammar school graduation class from 1918.

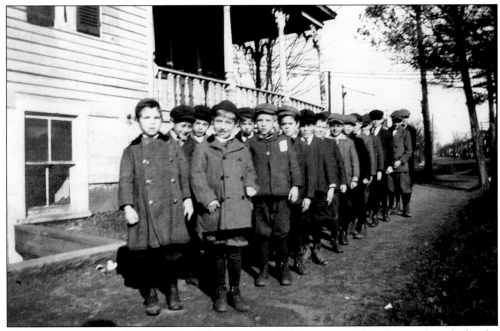

These young students from the Boys' House at Cooke's Corner are lined up and ready for the first day of school. For a time, the children walked to school in a line guided by the matrons, a practice hated by the children for obvious reasons.

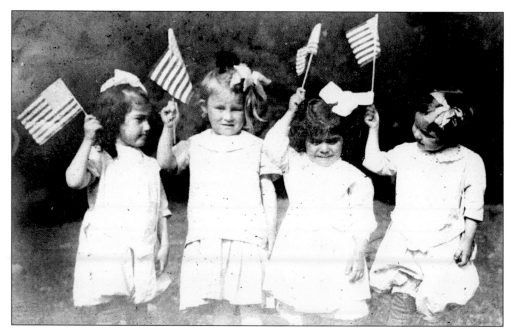

Holidays were occasions for fun and celebration, and living in a large group meant it could be done in a big way. Here are four little girls celebrating the Fourth of July, waving the red, white and blue.

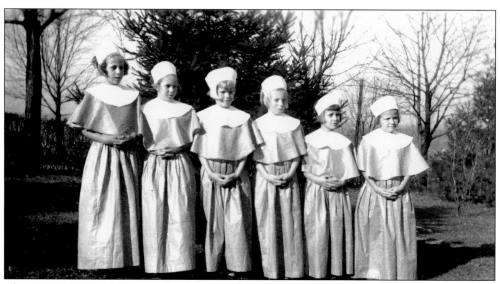

These six girls are celebrating Thanksgiving dressed as pilgrims.

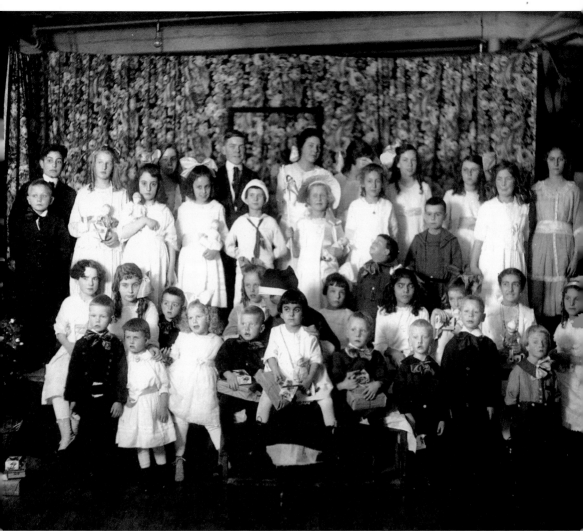

Children's Home alumni have many fond memories of Christmases past. Posing for the camera in one of the orphan houses, some of these children are holding gifts they received. Recalling the days as a young girl at the Children's Home, one alumna told of the excitement of Christmas: The children decorated a tree with strings of popcorn they had made. Waking up on Christmas morning, Santa Claus, Hannah Larson dressed for the part, paid them a visit and gave them each an apple, an orange, nuts, and candies. They gathered around the Christmas tree and sang carols. The best part, she recalls, was that they were together and so happy to have one another.

After the move to the hilltop, Christmas was celebrated with everyone together in the chapel. A little girl named Maggie wrote about the first special celebration on the hilltop on December 24, 1922: "Some men who looked like doctors 'cause they had funny caps on came and fixed the Christmas tree and when they finished it looked beautiful. It stood in the middle of the Chapel and there were red, green and blue balls on it and lots of other shiny things and pretty lights. I love those men and wish I could give them a big hug—specially because they invited Santa Claus."

Is this a very short Santa Claus in overalls? These mischievous little guys discovered the Santa Claus suit that was not hidden very well. The year of this great find was 1944.

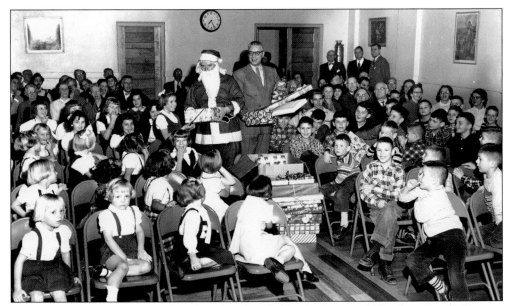

The late Judith V. Brown, a lifelong friend to the Children's Home and Klingberg Family Centers, wrote a special story in the *New Britain Herald* in 1956, describing Christmastime at the Children's Home: "And love from the community in the shape of roly-poly or tall-thin Santa Clauses, cartons of candy and ice cream, toys and clothing, seems to be flowing into the Children's Home with all the bright warmth of a Christmas candle. An integral part of December here is the spirit of Yuletide, and the parties are as numerous as 'visions of sugar plums.' "

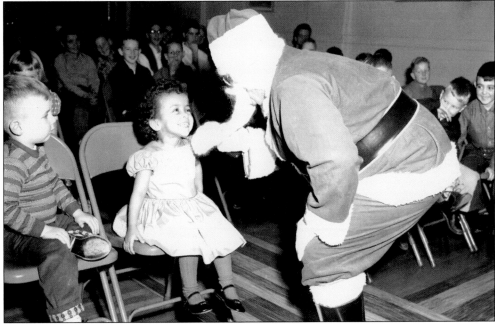

One of the younger children was led to believe that the unusual recurring visits by Santa Claus with every group that came to bring Christmas cheer was due to the fact that she was being very good. For the older children, so many parties were given by people they did not know that it was more an embarrassment than a celebration.

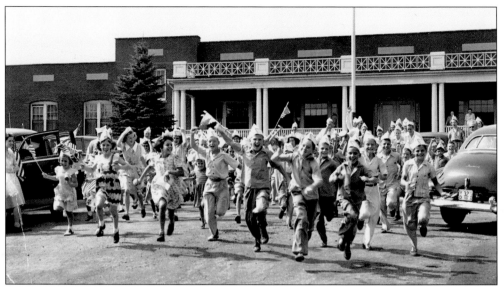

Because of the limited number of staff and the large number of children, it was impossible to leave the hill for all-inclusive activities unless a group of people from the community helped. The Hartford Exchange Club was one such group. The excitement on the faces of these children is evident as they race for the club members' automobiles that are standing ready to take them on an annual outing, called the Sunshine Special, to Lake Compounce. This photograph, taken in 1947, shows the first outing in several years since they had been suspended during World War II.

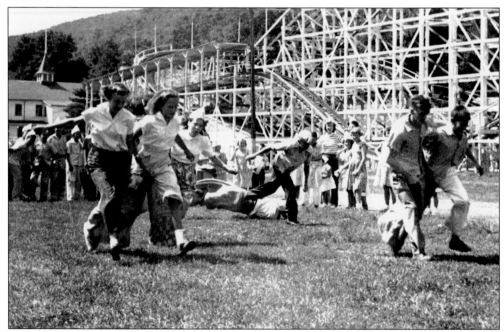

The Sunshine Special outing day at Lake Compounce was full of fun for the children and the Exchange Club members alike. It began with games and races in the field. After prizes were awarded and a picnic lunch was eaten, everyone headed off to the rides, featuring the "Wildcat" roller coaster.

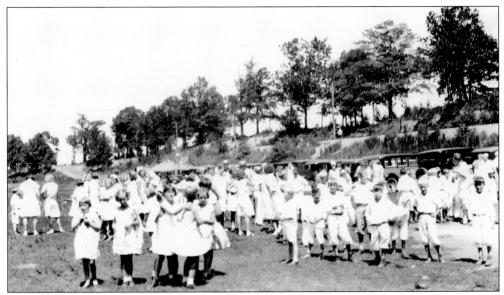

The Hartford Exchange Club's Sunshine Special was a tradition carried on for many years. This is a photograph of the festivities back in 1930.

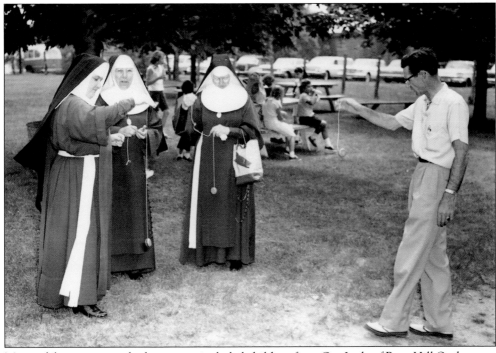

Many of the outings in the later years included children from Our Lady of Rose Hill Orphanage, also in New Britain. In this photograph, the sisters are having a little fun with yo-yos while the children are picnicking in the background.

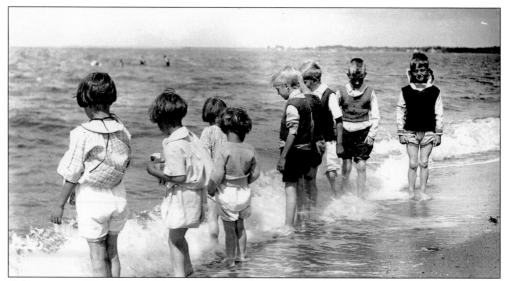

Other community groups and clubs sponsored outings for the children on occasion. In the photograph above, the children are enjoying the waves at Hammonassett State Park. Below, a group of boys gathers for a picture before leaving for a football game with a men's club in the 1950s.

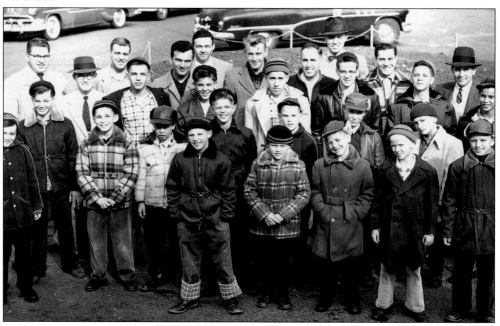

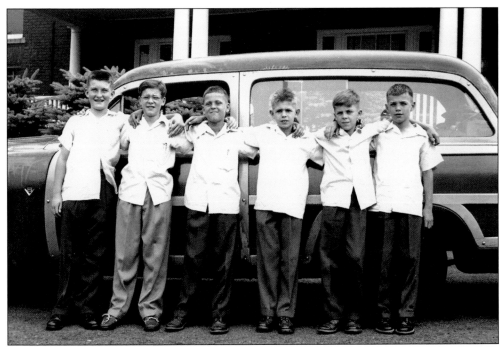

Going to summer camp was a rare occurrence at the Children's Home, but this group of friends is packed and ready to go. The picture was taken during the summer of 1953, and the boys were most likely going to attend the camp sponsored by the Elim Baptist Church. They are leaning against the Children's Home's Woody station wagon.

In the early 1960s, several children from the Children's Home appeared on a local children's television show, *The Ranger Andy Show*, broadcast by Channel 3 in Hartford. The show was aired live every weekday afternoon, featuring Ranger Andy and a group of local children.

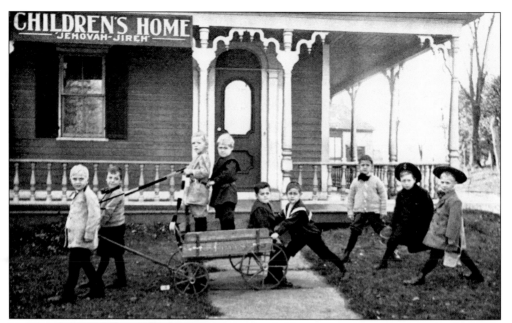

In the early years at the orphan house, play for the children was simple and created by their own imaginations. Here, in one of the first photographs taken at the house at Cooke's Corner, is a group of boys making their own parade for the camera.

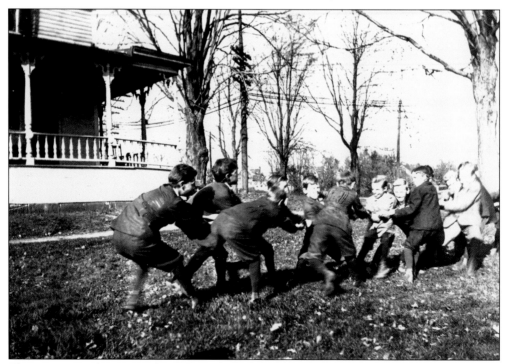

There were very few toys at the orphan houses, but the children played together with the simple things they found. Here is a tug-of-war in the side yard of the Boys' House at Cooke's Corner.

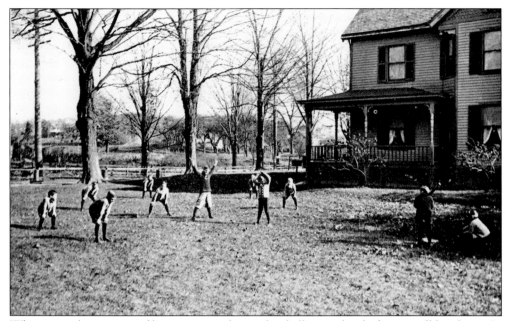

Whenever a large group of boys gets together with a ball, some kind of game will break out. In the photograph above, the boys are playing a game of baseball. Below, the first Children's Home football team poses for a team picture. Note the "CH" on the captain's shirt. Both of these photographs were taken before 1910.

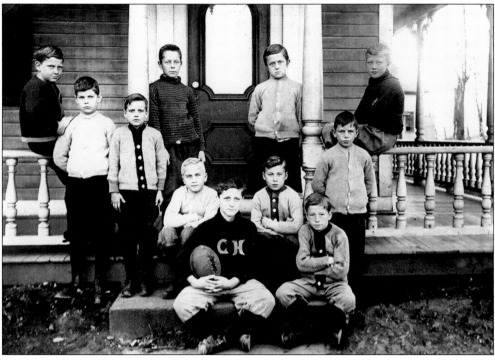

In this 1919 photograph, five boys are building with what looks like an Erector set. Stanley Works in New Britain was one of the early manufacturers of toy building sets like this one.

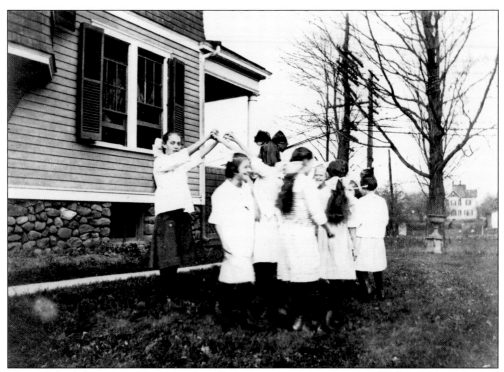

The girls had their own games to play. Here they are playing London Bridge in the side yard of their house at Cooke's Corner. The vacant lot seen here in the background, across Corbin Avenue, is the present location of the Jerome Home.

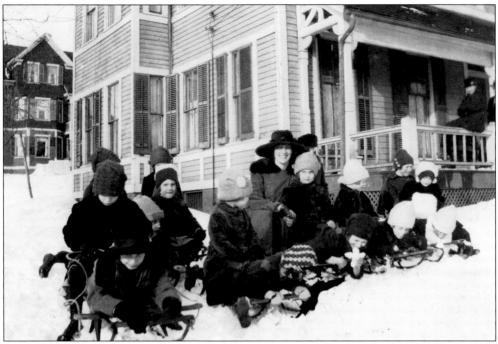

When the girls lived in the Burr House on Hart Street, located on the hill near New Britain General Hospital, sledding was a popular activity. When all the children were moved to the hilltop at the end of Linwood Street, sledding became a Children's Home tradition, with many people from the community joining them. Of course, there were never enough sleds for everyone.

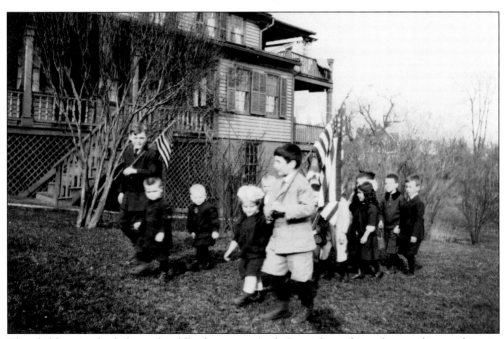

The children in the baby and toddler house on Arch Street have formed a parade, marching in a row, wearing their best knickers and waving flags.

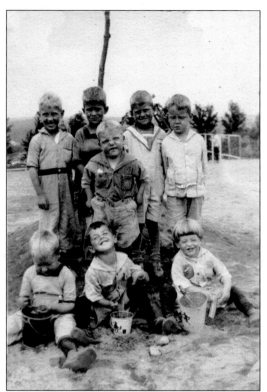

When all the children were moved to the hilltop in 1922, they had wide-open spaces in which to roam and to play. The backyard of the main building was left as a dirt lot for several years, and there was a pile of sand in the middle for the kids to play in. These young boys, who look a lot like Spanky's Our Gang, are enjoying the sand pile.

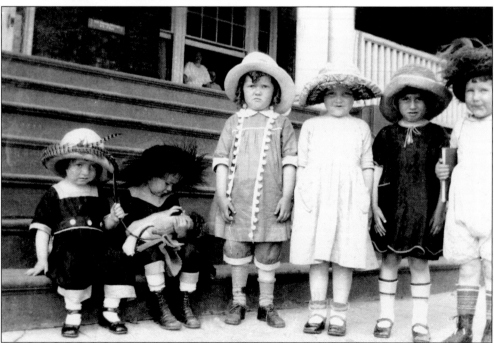

These little girls are having fun with their dress-up clothes. Judging by the expressions on their faces, especially the Shirley Temple look-alike in the middle, they do not seem to appreciate being interrupted by the photographer.

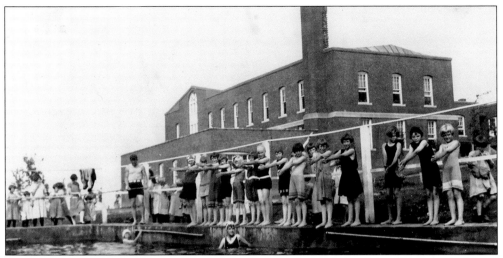

Shown here is the swimming pool that the older boys dug and that John Klingberg had lined with cement soon after the move to the hill. Girls and boys swam on alternating days. The above photograph is of the girls enjoying their time in the pool. Below, the boys are modeling their swimwear. It looks very similar to what the girls are wearing. Both photographs were taken in the mid-1920s.

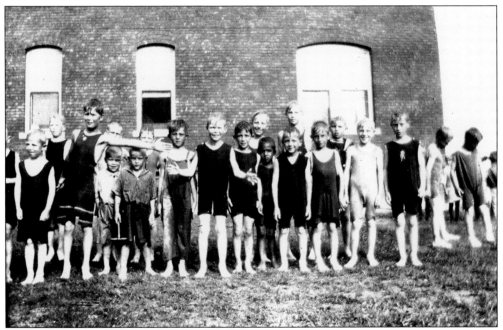

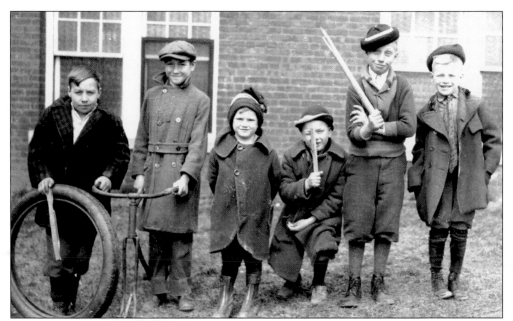

Life in an orphanage, as a rule, was what you made of it. These six young friends from the 1920s did not have what many children their age in the community had, but they had each other. Here they have created their own toys out of sticks, an old tire, and a bicycle frame and handlebars.

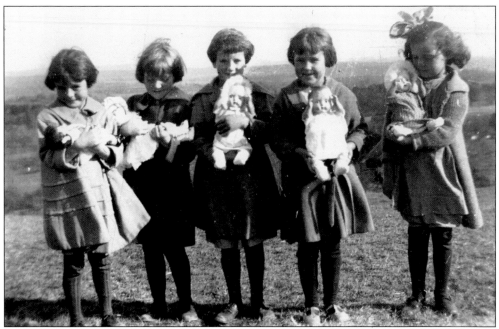

There were times at the Children's Home when the girls did not have their own dolls or many other personal possessions, but everything was shared with the group. One alumna, who came to the Children's Home when she was less than a year old and stayed until she was 13, thought that not having her own toys or many to share between them taught her to value relationships with family and friends rather than possessions.

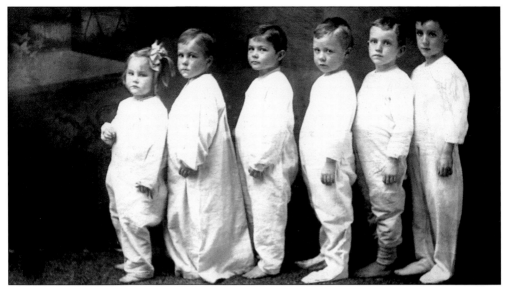

Many of the children who came to the Children's Home in the first several decades, as those shown here in 1905, knew that if they had not been taken in by John Klingberg, they would have been living in very desperate situations. At the beginning of the 20th century, there were no laws to protect children from being abandoned by parents who could not or would not raise them.

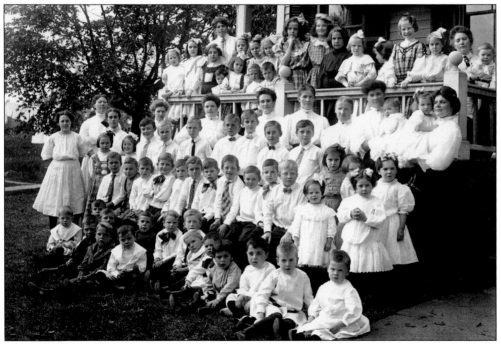

Very few children living at the Children's Home were true orphans, that is, left alone by the death of both parents. Many had lost one parent, through death, divorce or other circumstances, and the remaining parent did not have any means of support to raise their children. Some did the only thing they could. They found the best orphanage to raise their child or children. This is the Children's Home family in 1906.

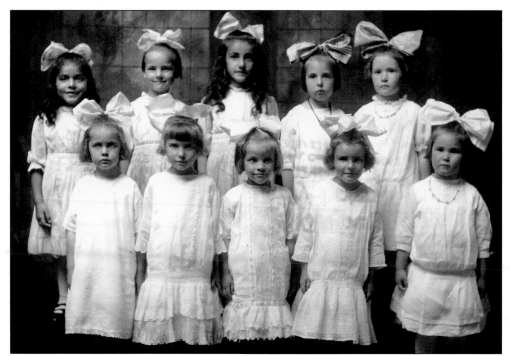

Many children, before coming to the Children's Home, were moved from one place to another. John Klingberg promised the children that this was now their permanent home and that they did not have to fear having to go anywhere else, unless their parent's situation changed. One alumna recalls that she was in three different foster homes in the 1930s and knew that none of them wanted her. John Klingberg's promise was a welcome one, indeed.

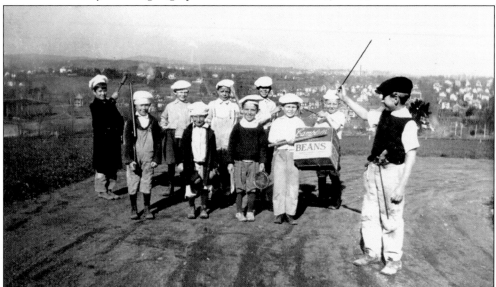

Unlike being in the "Campbell's Beans" band, life at the Children's Home was not all fun and games, as many photographs in this book may indicate. Life in a large group meant structure, discipline, and hard work, not unlike that experienced by some families in the community during this time. For the most part, life was good, but life was also hard.

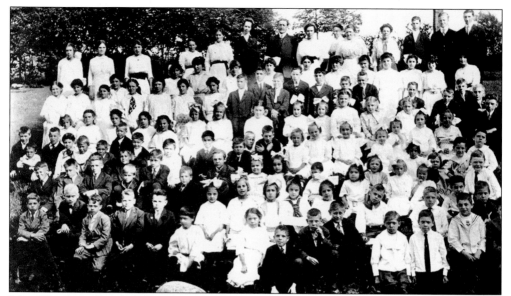

John Klingberg founded the Children's Home based on his faith in God and his belief that prayer was vital to a successful life. He added his mother's philosophy: "Hard work solves many problems, and you should never seek an easy life." John Klingberg (back row, center) poses with his children, family, and matrons in this photograph taken at Walnut Hill Park in 1915.

Every year, many Children's Home alumni return to Klingberg Family Centers, where they are welcomed home. With both laughter and tears, they tour the old buildings, look through the photo albums, and tell their stories. It is most gratifying to hear the "home kids" tell how they learned the lessons and kept the faith of John Eric Klingberg.

AFTERWORD

Klingberg Family Centers is proud of its great heritage of compassion, faith, and vision given to us by its founder, John Eric Klingberg. Believing that every child should have a family, he stepped out in faith and gathered in the needy children, creating a large, loving family for them. This was radical thinking in his day. As the decades passed and society changed, this foundational belief in the family did not change. Haddon Klingberg Jr. began transforming the Children's Home structure to fit the changing needs of society. The goal became preserving and restoring families for children.

Today, the mission and values of Klingberg Family Centers are based on John Klingberg's foundational belief that every child should have a family. Currently, there are over a dozen programs to preserve and restore families for children through residential, special education, and community services. In addition, foster home and adoption programs are in place to find families for children when needed. For more information about Klingberg Family Centers, contact Klingberg Family Centers, 370 Linwood Street, New Britain, CT, 06052, www.klingberg.org.

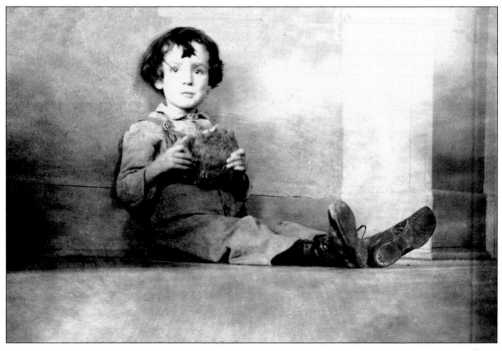

"More things are wrought by prayer than this world dreams of."

—Tennyson